Etna Hotel, Etna, California

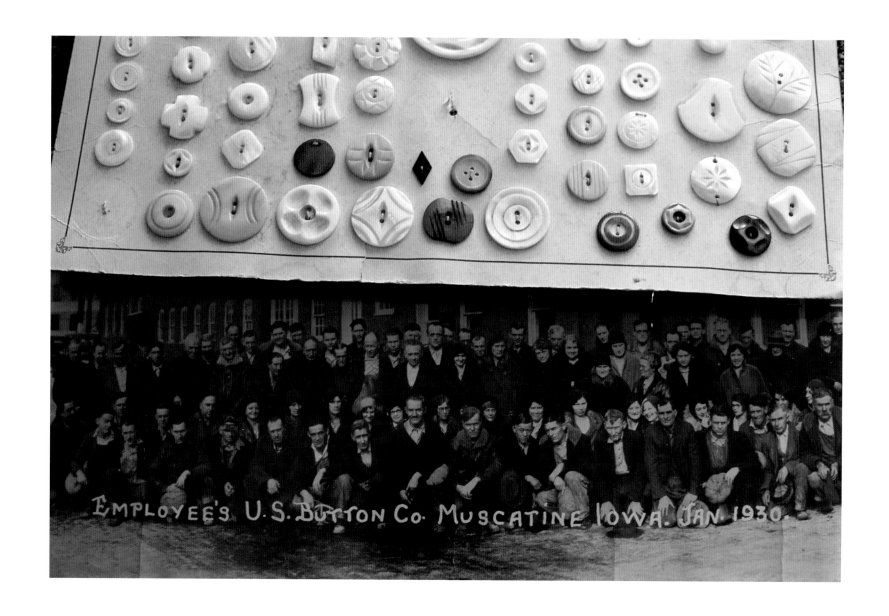

Pearl Button Museum, Muscatine, Iowa

THE LIFE OF A PHOTOGRAPH

SAM ABELL

FOCAL POINT

NATIONAL GEOGRAPHIC
WASHINGTON, D.C.

RUFOUS-FRONTED ANTTHRUSH, MADRE DE DIOS RIVER, PERU

Seeking the Picture 6

Setting the Scene 26

Road Trip 42

Portraits 62

Portrait of a People 80

Land Sea Sky 98

Wild Life 116

The Built World 136

Just Looking 158

Seeing Gardens 176

The Life of a Photograph 194

SEEKING THE PICTURE

I WAS HURRYING TO AN APPOINTMENT when something stopped me. It was an austere, brilliantly lit plaza. I took it in, stepped back to include the black edge of the building beside me, and gathered myself to make a photograph. Moments later a woman rounded the corner and completed the composition.

"Woman on the Plaza," with its distinct horizon, snow-like surfaces, wintry wall, stunning sunlight, sharp shadows, and hurrying figure would become the most biographical of my photographs—an abstract image of the landscape and life of northern Ohio where I grew up and first practiced photography.

I didn't realize all of that at the time. But I knew what had just happened. Once again something had stopped me. I'd taken it in, composed and waited, then photographed. These small sequential acts amount to a transaction between two lives—the external life of encountered experience and the imaginative inner life of the individual photographer. It is at this intersection of the inner and outer worlds that the life of a photograph begins.

It often begins imperfectly. Life rarely presents fully finished photographs. An image evolves, often from a single strand of visual interest—a distant horizon, a moment of light, a held expression. Over time I grew interested in these first imperfect impressions. They revealed what had initially stopped me. A few had a rough vitality. All contained evidence of the photograph to be.

Sometimes there's more than one finished photograph. By presenting alternative images side by side or in sequence this book suggests the process of seeking the picture—a process with no absolute ending as time and thought continue to shape the life of a photograph.

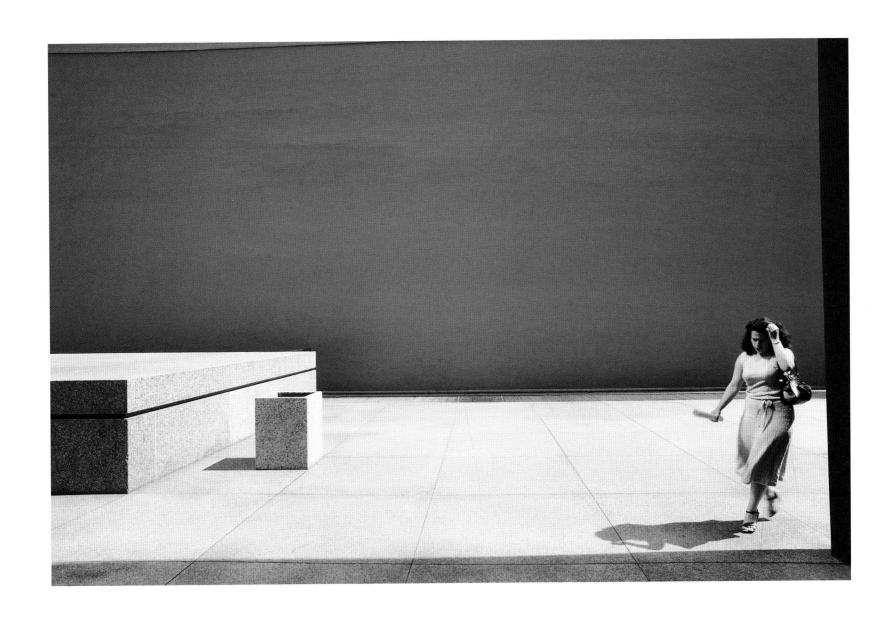

TORONTO, ONTARIO

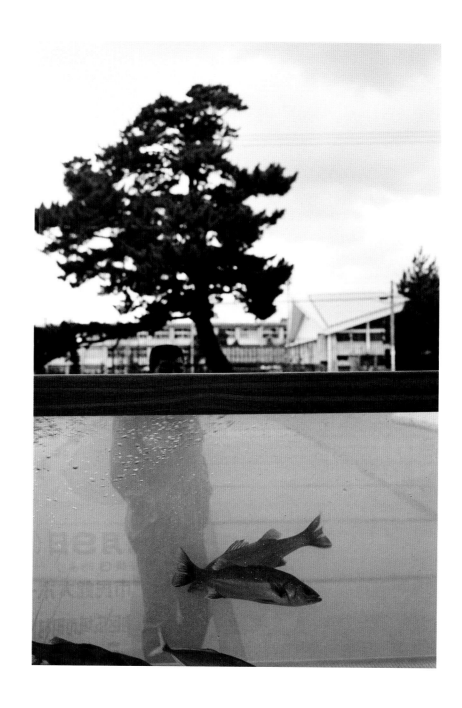

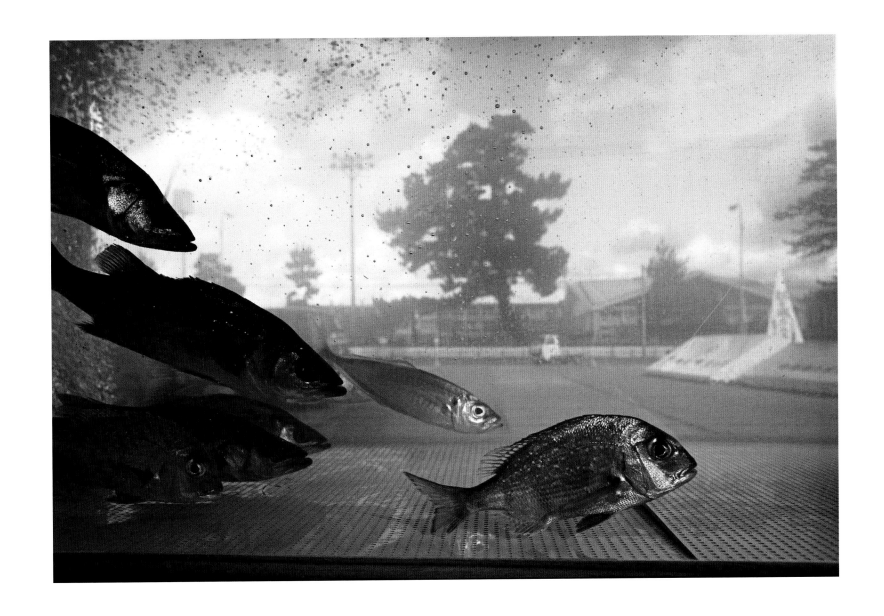

Two views of a fish tank and city landscape, Hagi, Japan

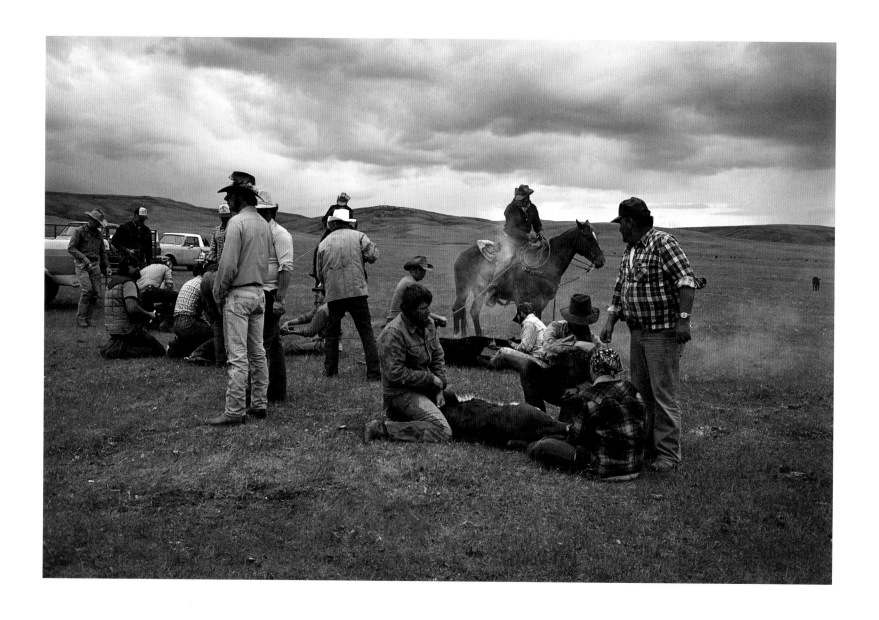

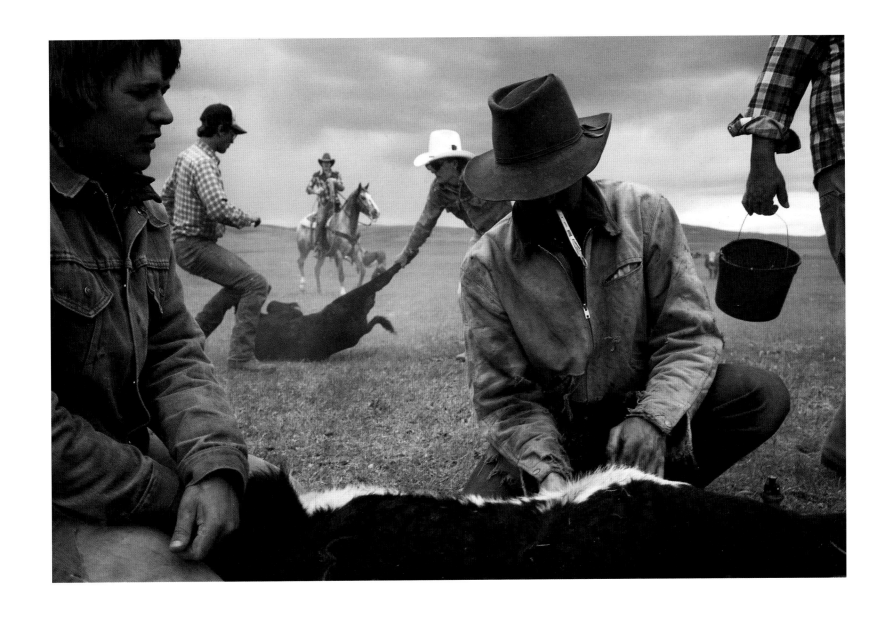

TWO VIEWS OF THE ANNUAL BRANDING AND CASTRATION,
KEN ROSMAN RANCH, UTICA, MONTANA

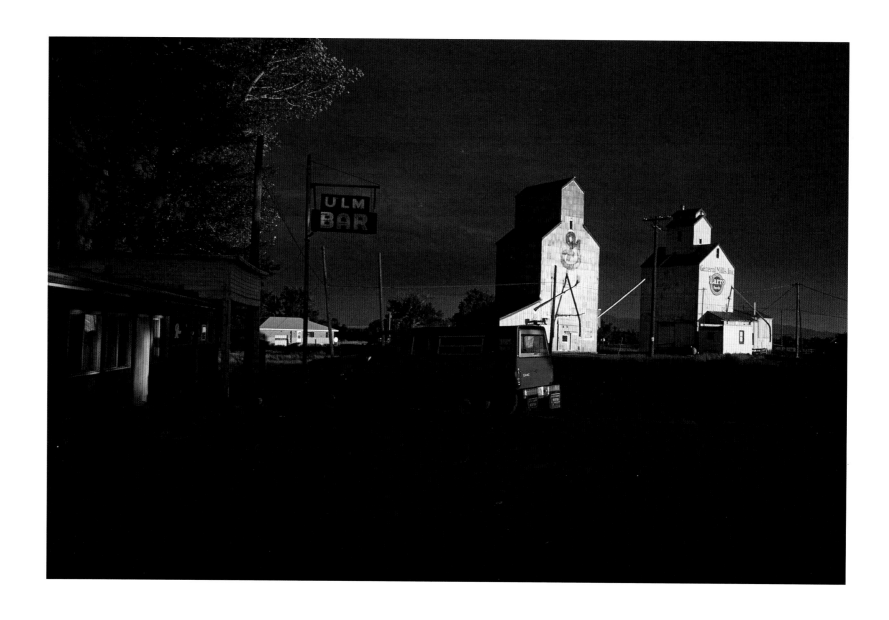

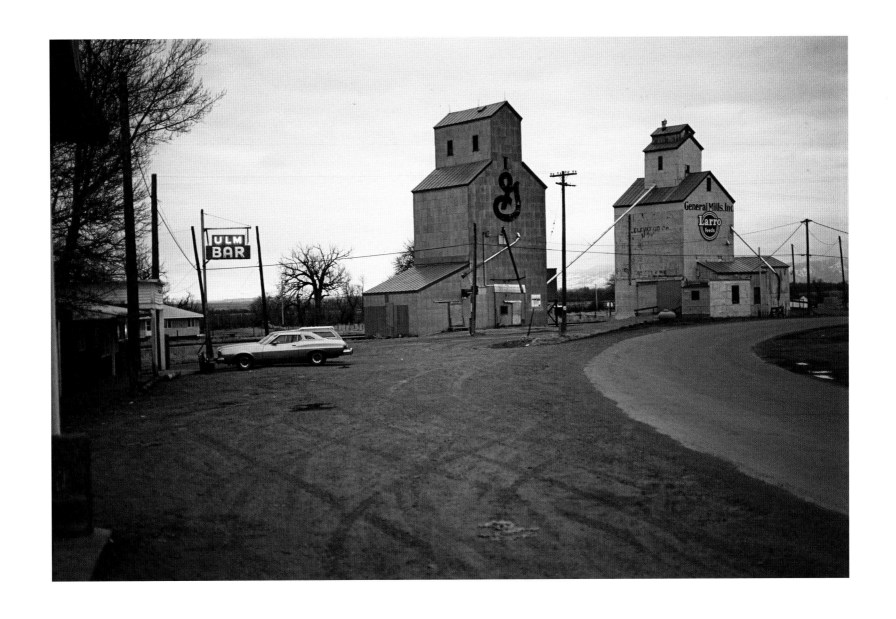

Two views of the grain elevators and bar, Ulm, Montana

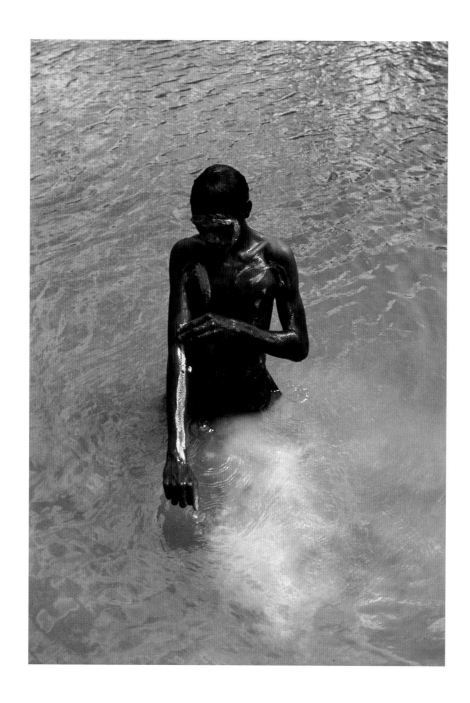

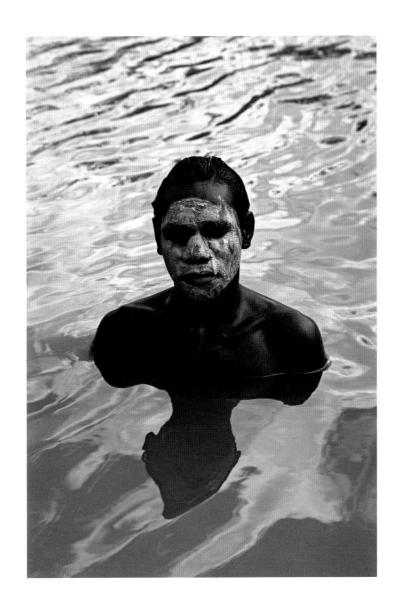

TWO VIEWS OF TREMAINE GILROY WENSLEY LUKE, STRATHBURN STATION,
CAPE YORK PENINSULA, AUSTRALIA

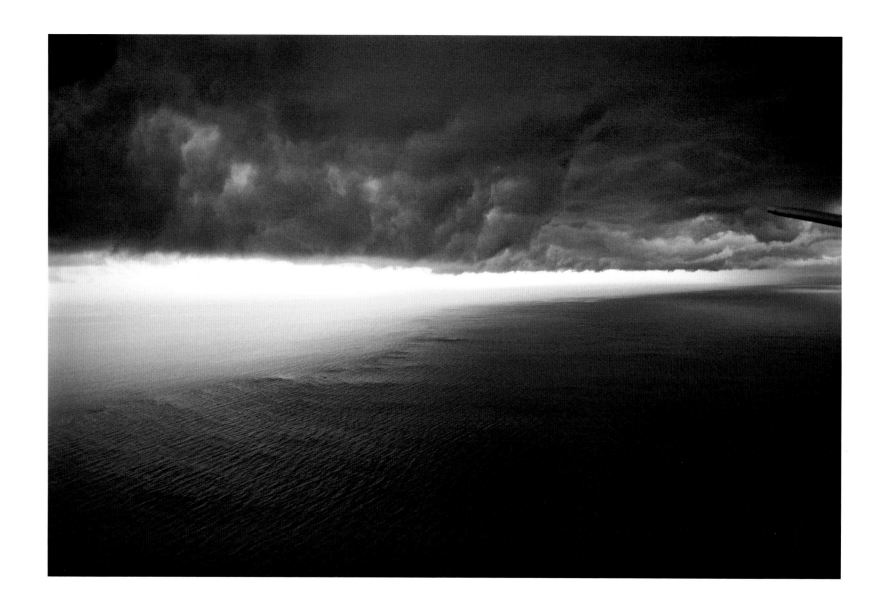

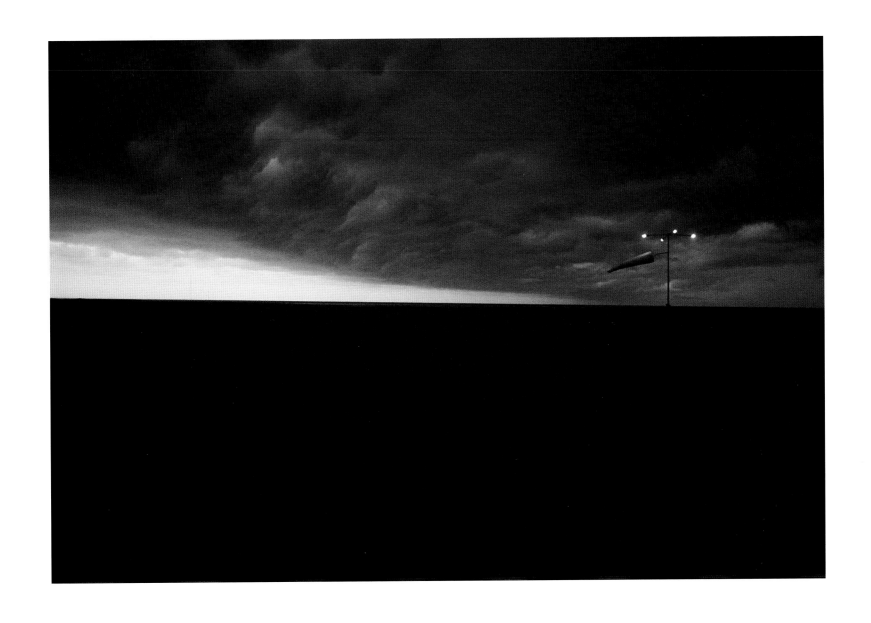

AERIAL AND GROUND VIEWS OF A CYCLONE, THE KIMBERLEY COAST,
WESTERN AUSTRALIA

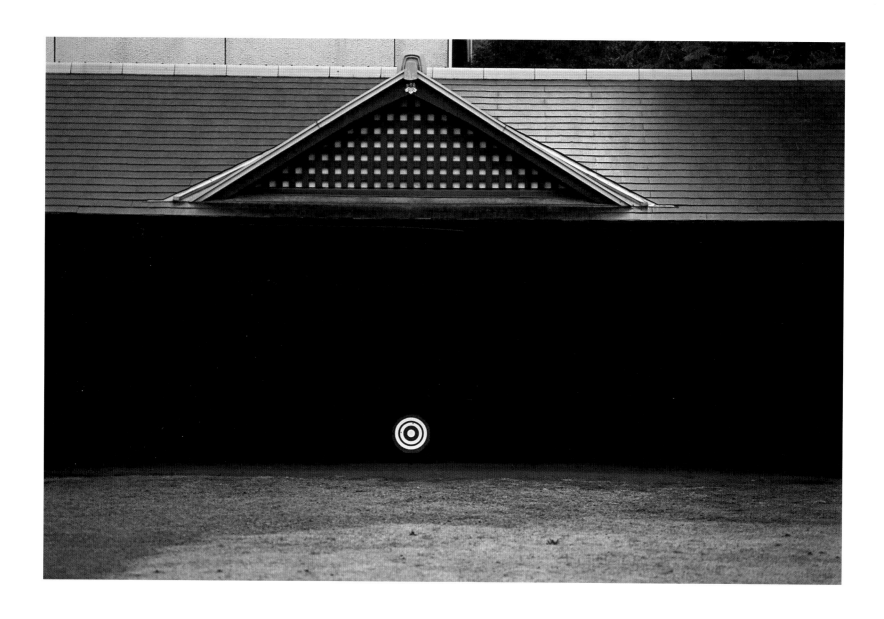

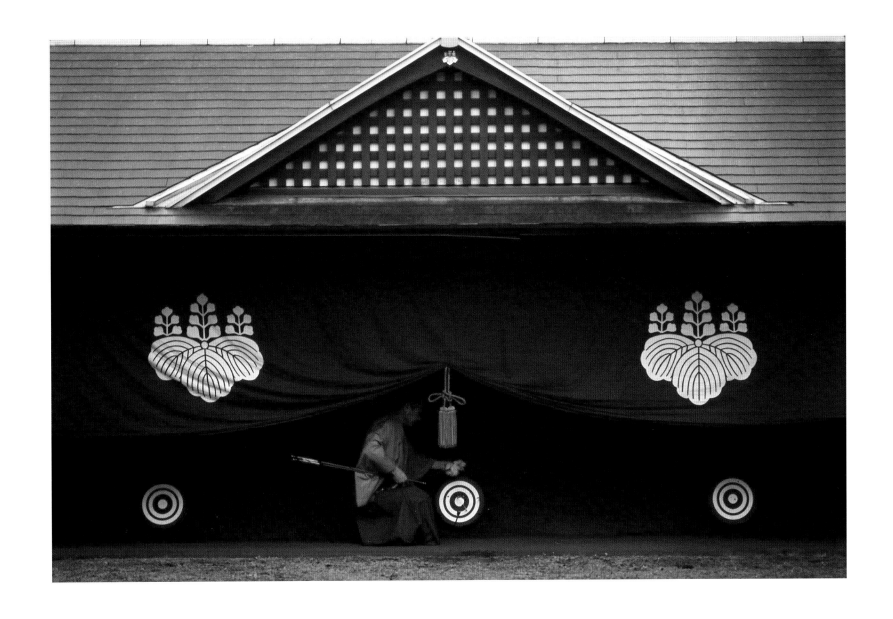

Two views of the Zen archery pavilion, Imperial Palace, Tokyo

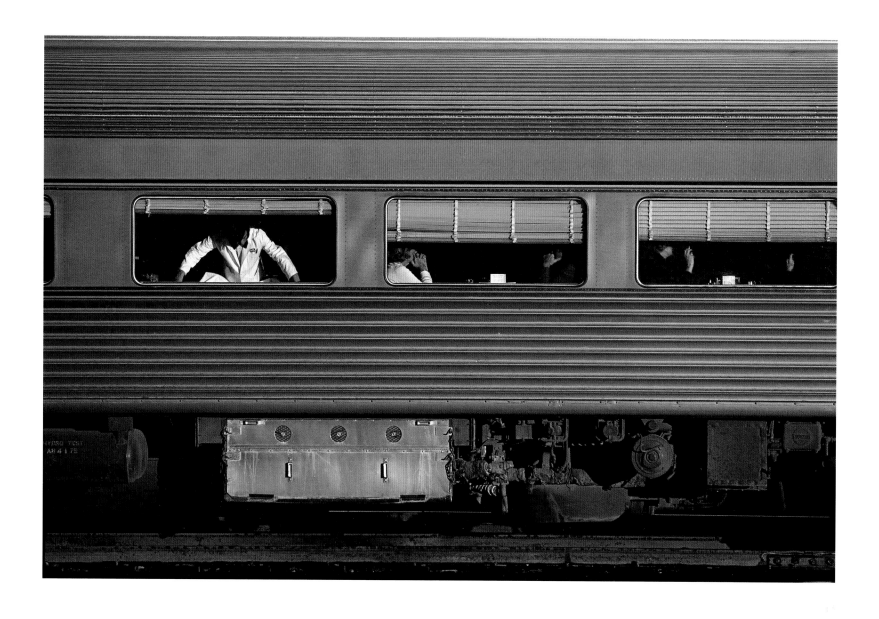

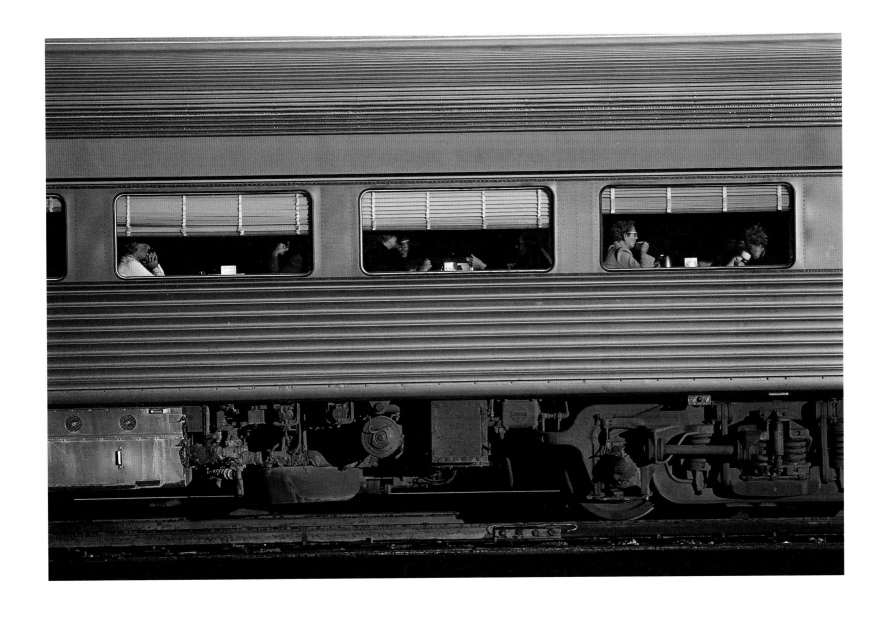

TWO VIEWS OF THE TRANS-CANADA TRAIN, THUNDER BAY, ONTARIO

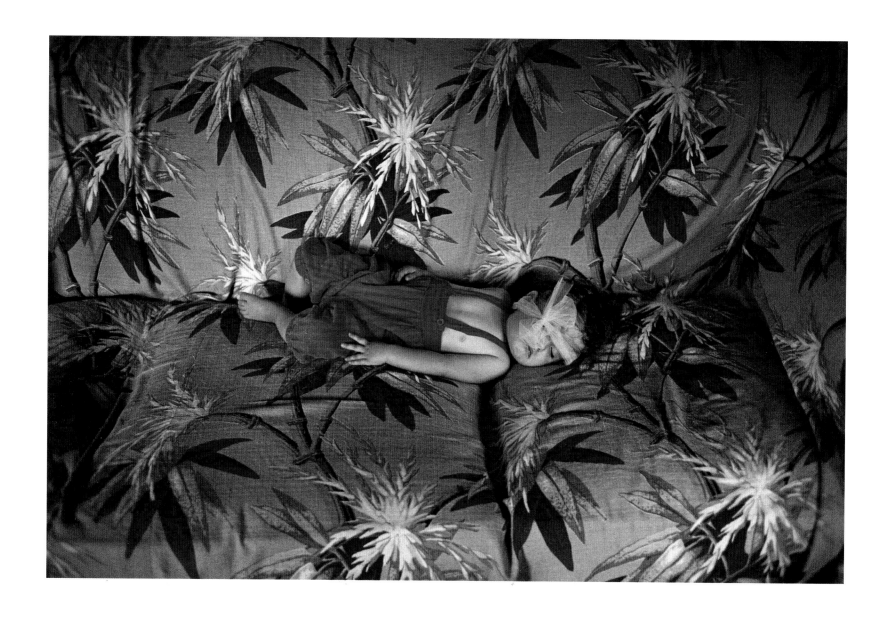

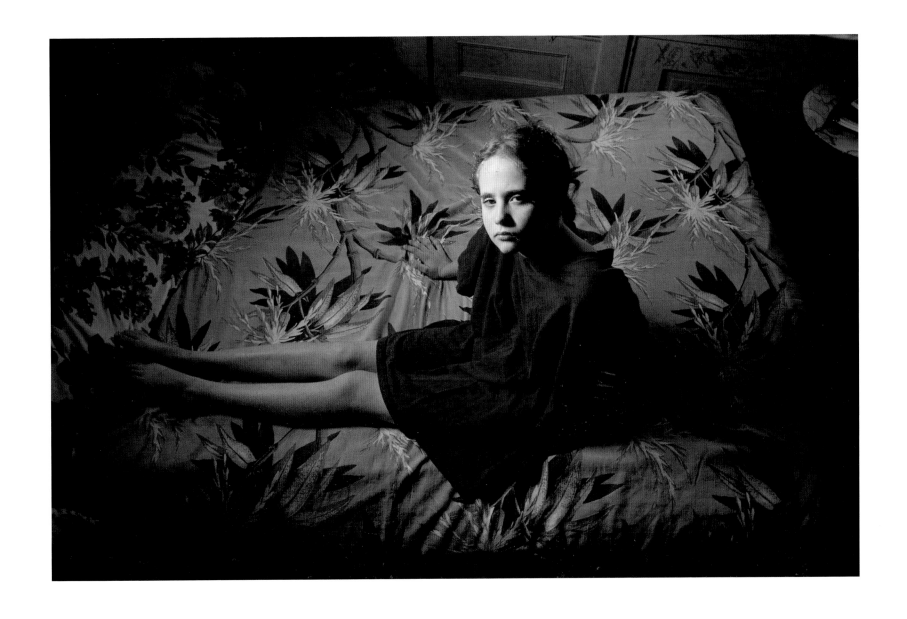

Two portraits of Azzurra Lockwood, fourteen years apart,
Seattle, Washington, and Portland, Oregon

THIS PICTURE OF A TABLE SETTING OVERLOOKING a street was chosen for the cover of this book because it well represents the style and content of the work within.

But to me the picture also has its own literary and imaginative implications. It's like a scene from a short story that will soon change. The woman will walk off, the bus pull out, the light fade. Someone else will sit at this table. But for a moment the scene is suspended and belongs to anyone who can picture being here.

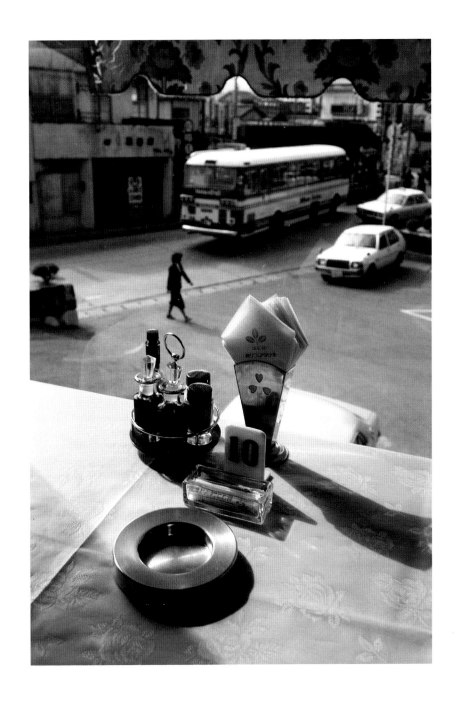

HAGI, JAPAN

SETTING THE SCENE

MR. TAKAHASHI WAS ANGRY. The writer Robert Poole and I had privately arranged an invitation to the Emperor's Spring Garden Party. As an official of the Imperial Household Agency Mr. Takahashi's job was to control our movements within the Palace. For reasons we couldn't understand he didn't want us to see the Emperor even from a distance. But now we were here, on an Embassy invitation he hadn't issued.

"You must leave twenty minutes before the Emperor arrives! And you must not leave this spot!" This spot was just inside the Palace entrance, far from the ceremonial center where the party was to be held.

I turned to see what was possible. Immaculate new turf rolled from my feet to a pond thickly planted with Japanese iris and bordered by azaleas, all framed by a forest. A soft rain fell. Space, the rarest thing in Tokyo, presented itself. I went to work, waiting.

To me the setting is often the first subject of a photograph. In this case the strolling dignitaries complete the composition. Together they suggest something about ceremonial life in the Palace.

I was taught to see settings by my father on our photographic outings together. He was an amateur so under no pressure to produce. I never saw him force a photograph. Instead I'd watch him size up situations, then wait.

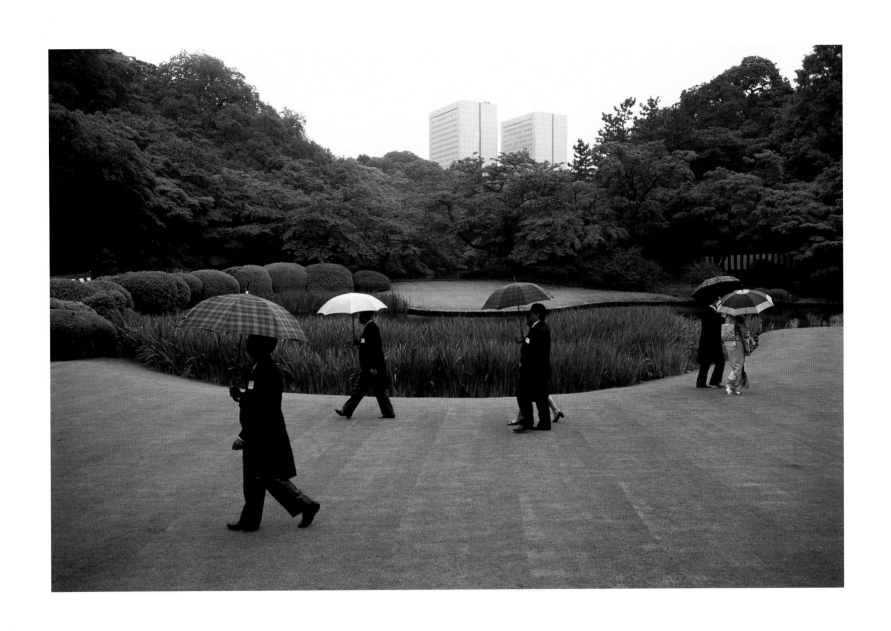

Arriving guests, the Emperor's Spring Garden Party, Tokyo

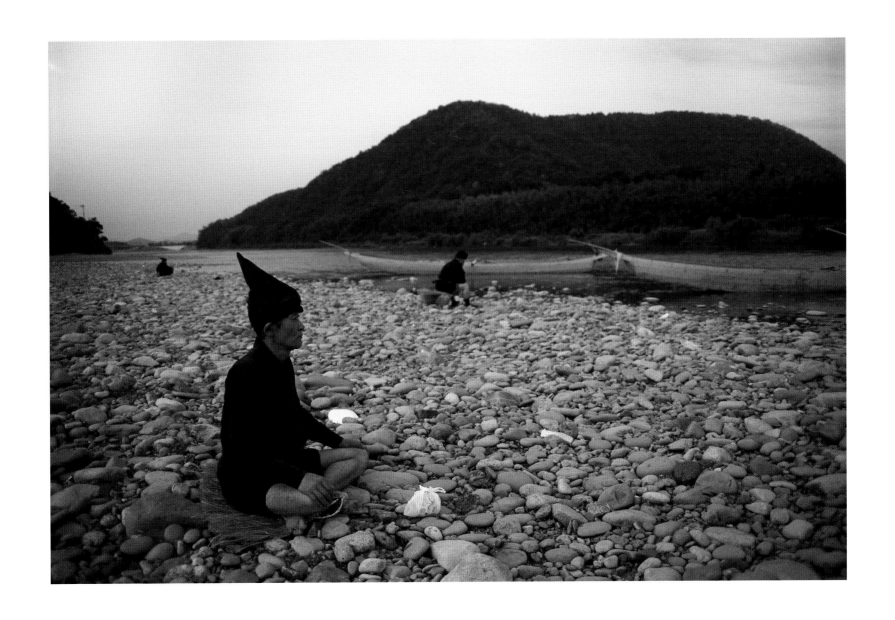

HIDEO SUGIYAMA, THE EMPEROR'S CHIEF CORMORANT FISHERMAN, MEDITATING
BEFORE FISHING ON A CLOSED STRETCH OF THE NAGARA RIVER, JAPAN

 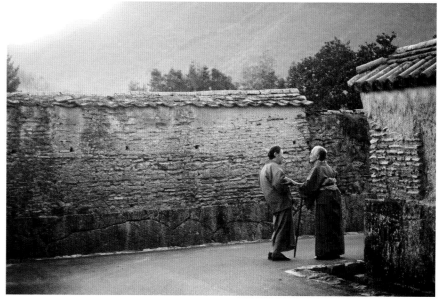

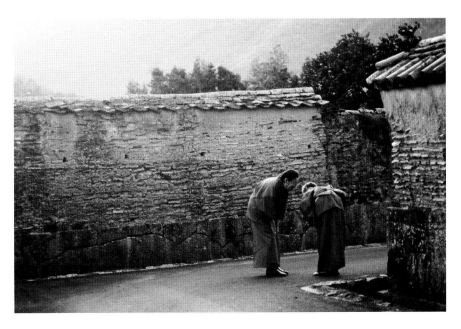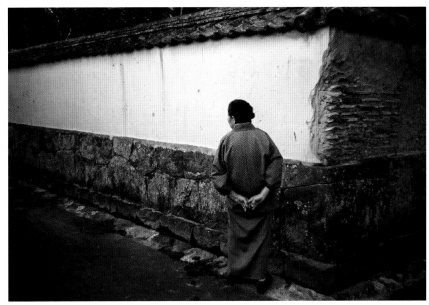

Two friends parting, Hagi, Japan

WHAT ATTRACTED ME TO THIS SCENE was the man venerating a shrine in a city courtyard. The shrine was a world within a world. It had its own frame and within that its own figures, lighting and drama.

But street life has its own choreography often featuring momentary arrangements of strangers acting out their own dramas. In this scene a woman with a cane walks past the man while in the distance another woman washes windows. Each woman occupies her own space. Combined with the man they give to the photograph a fleeting equilibrium.

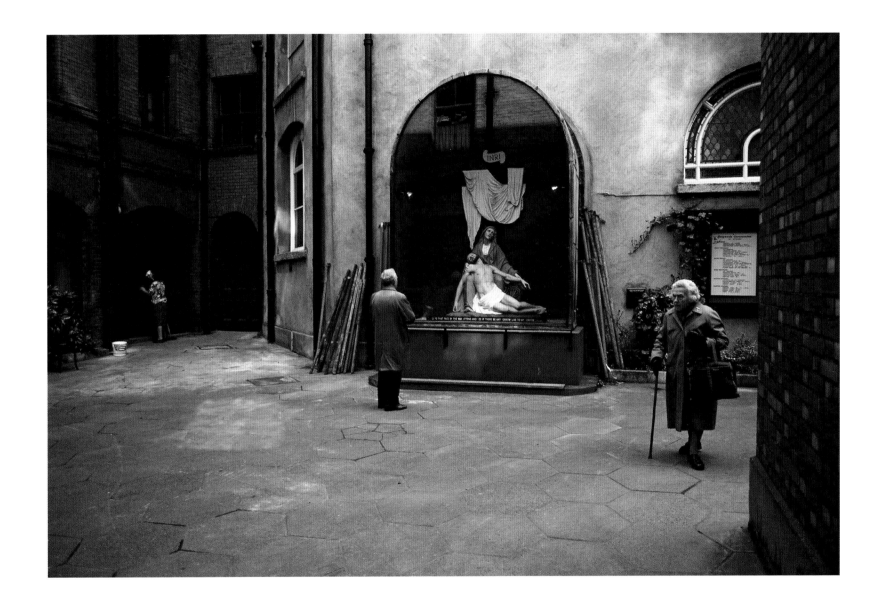

DUBLIN, IRELAND

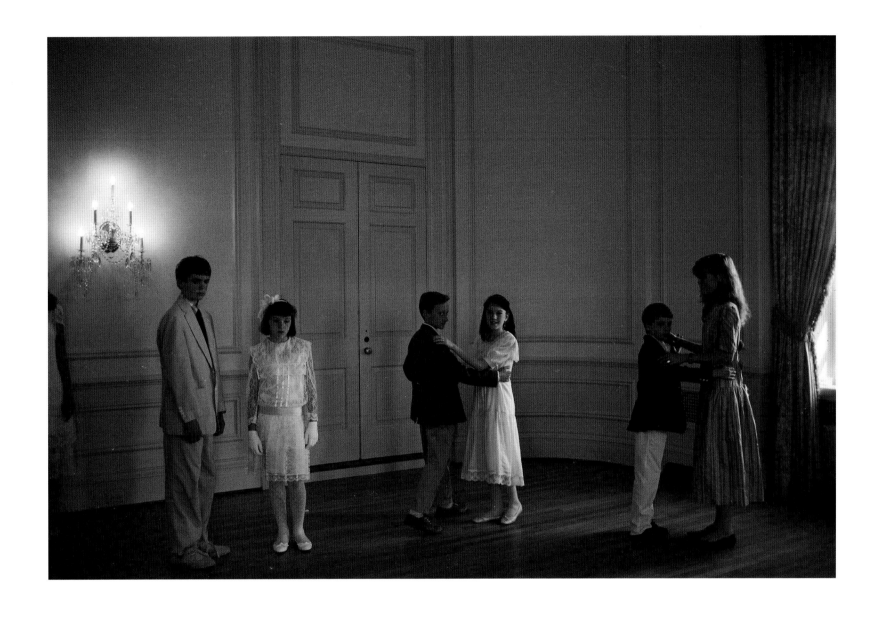

DANCE CLASS, FARMINGTON COUNTRY CLUB, CHARLOTTESVILLE, VIRGINIA

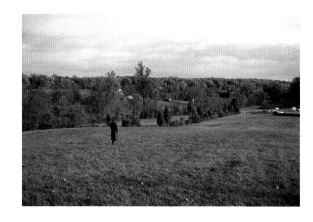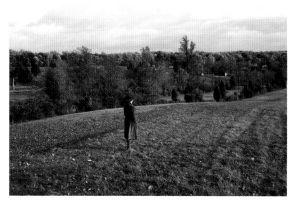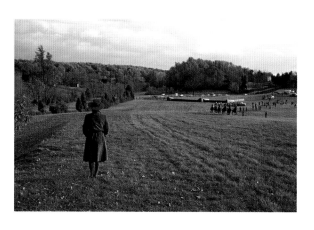

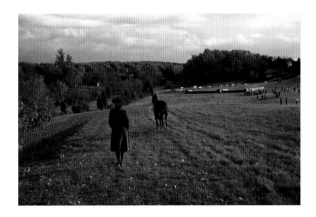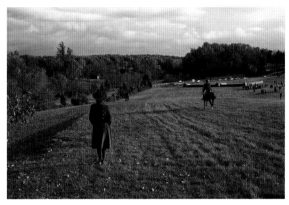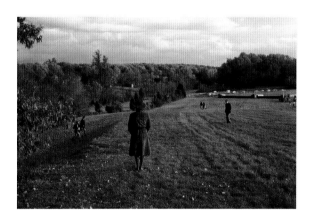

Woman in a landscape, a steeplechase race, a riderless runaway horse, and spectators crossing the course, Montpelier, Virginia

As a photographer my intent is to bring the world under my aesthetic control. In its visual chaos the world doesn't ordinarily comply with this. The lighting, structure and movement of a situation is often at odds with itself and with me. Rodeos are like that. Double it for an Indian rodeo.

At the dynamic Crow Fair Rodeo my head and photography were spinning from the unpredictable energy of the events. Late in the day I realized the rodeo was taking my photographs, not the other way around. Before it was too late I settled myself on a layered composition of sharp horizontal bands with an interior frame and let the action come to me.

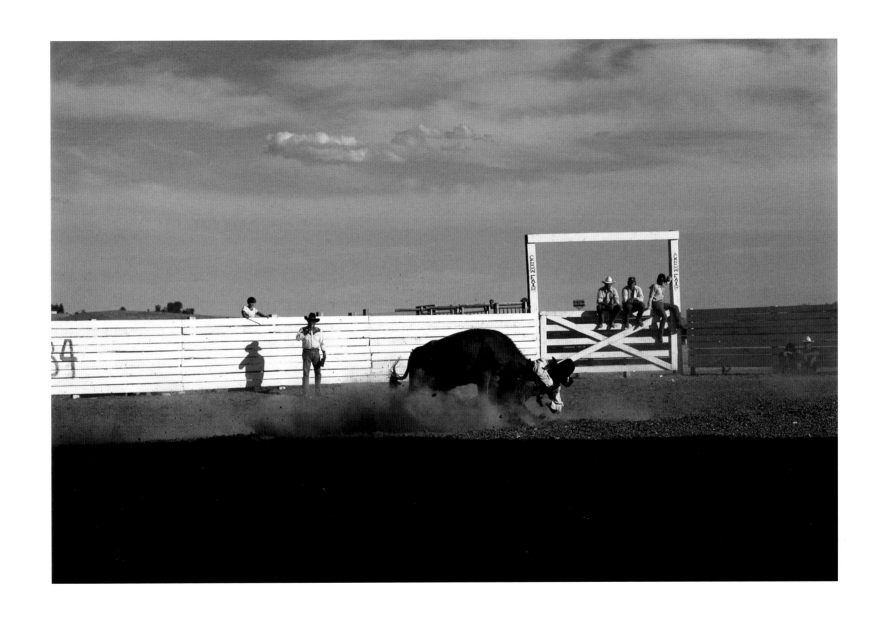

BULLDOGGING, CROW FAIR, CROW AGENCY, MONTANA

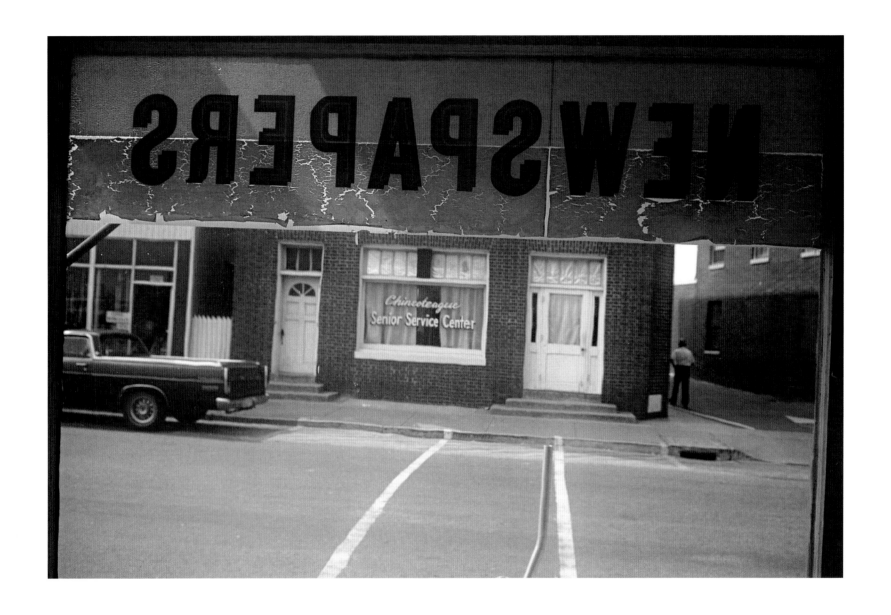

CHINCOTEAGUE, VIRGINIA

ROAD TRIP

I SPENT MORE TIME IN CARS than I ever expected to and saw a lot of the world through windshields.

Many of the car trips were ordinary errands or the defensive grind of interstate highways. But some trips were epic experiences of space and time travel where for days the only sensation was of speed. On such trips I'd think about photographing that sensation. One solution was to symbolize travel by photographing the way speed wore things down.

A cracked windshield, sharp streaks of mud, weather-worn decals, a dog's face in the wind and disappearing tire tracks all became subjects that spoke to me of speed.

Trips like these presented other subjects having to do with the pervasiveness of car culture. The filling stations, parking garages, cars for hire and impending accidents were all there to be taken up.

Photography's long established connection with travel has been about destinations. By photographing travel itself I kept my mind focused on the significant act of getting there.

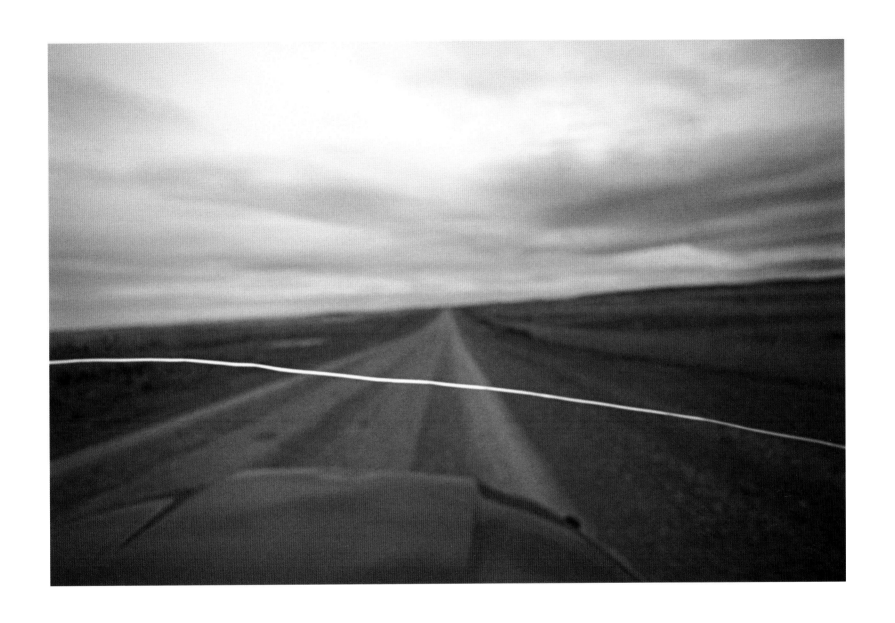

ROAD TO RIO GRANDE, TIERRA DEL FUEGO

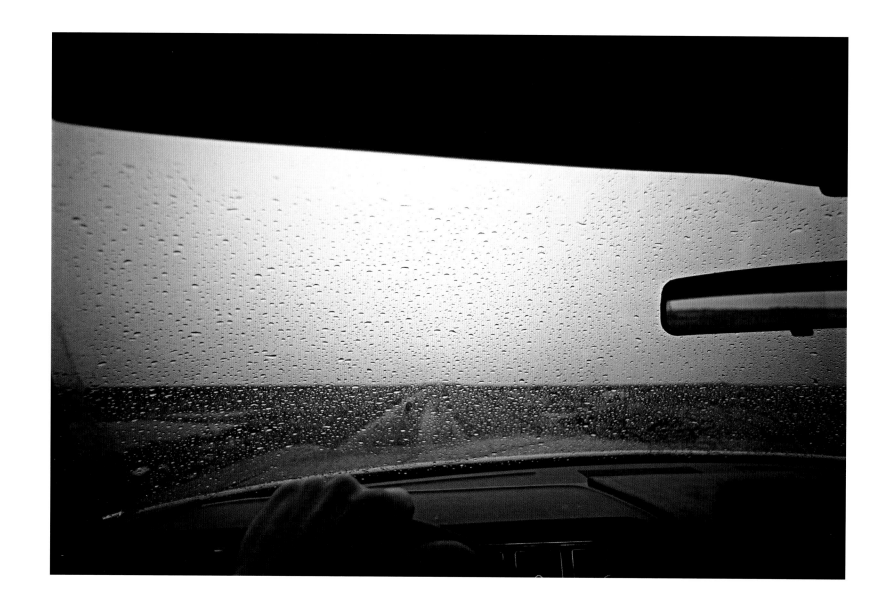

THE BARRENS, AVALON PENINSULA, NEWFOUNDLAND

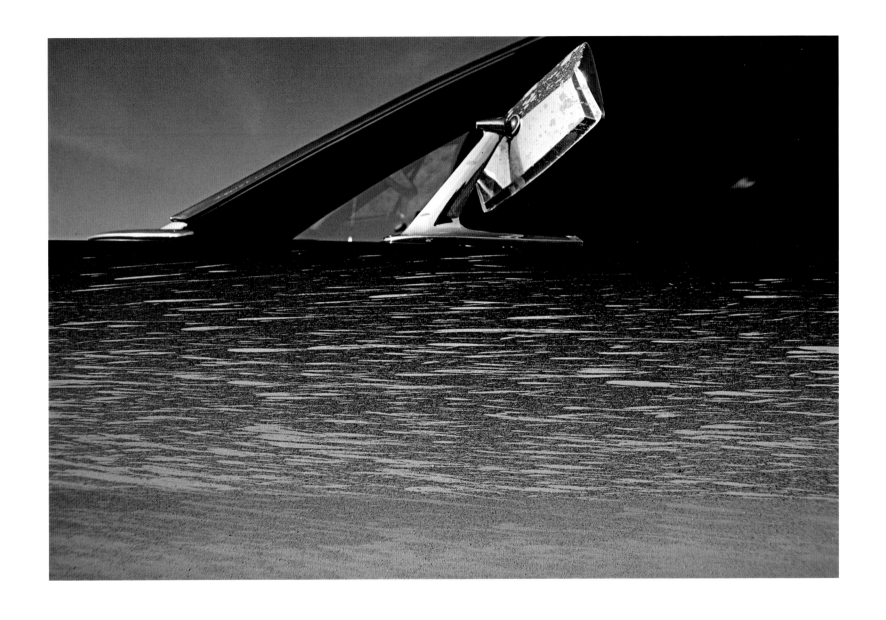

COLINET, NEWFOUNDLAND

THE FANTASY OF THE GREAT AMERICAN ROAD TRIP is lived out every day in Australia. There's a saying in Western Australia that if you need a quiet camping place just take two right turns off any highway and throw down your swag. No one else will be there.

In my experience the same statement is true in north, south and east Australia where this photograph of a pregnant woman in a pink bikini standing forth like a statue against the sky was made.

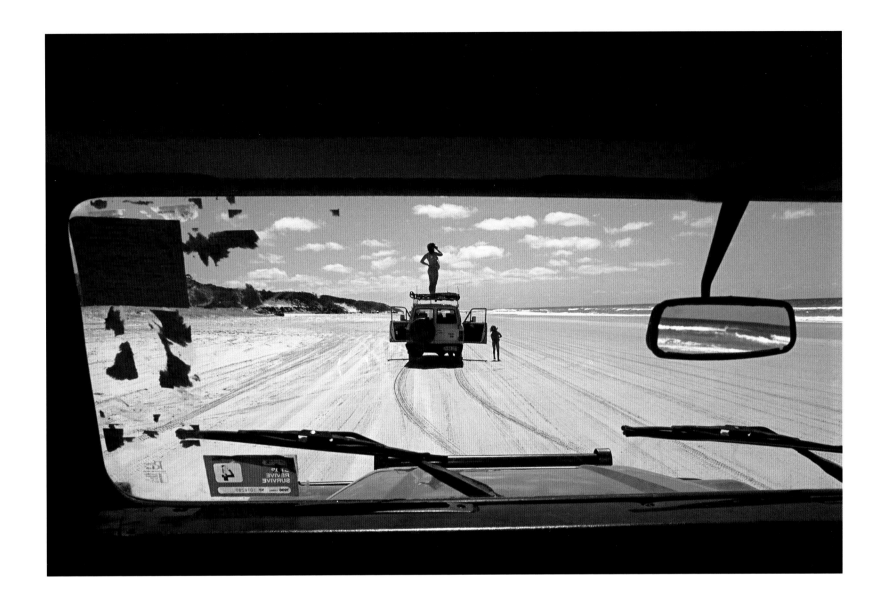

Whale watching, Fraser Island, Queensland

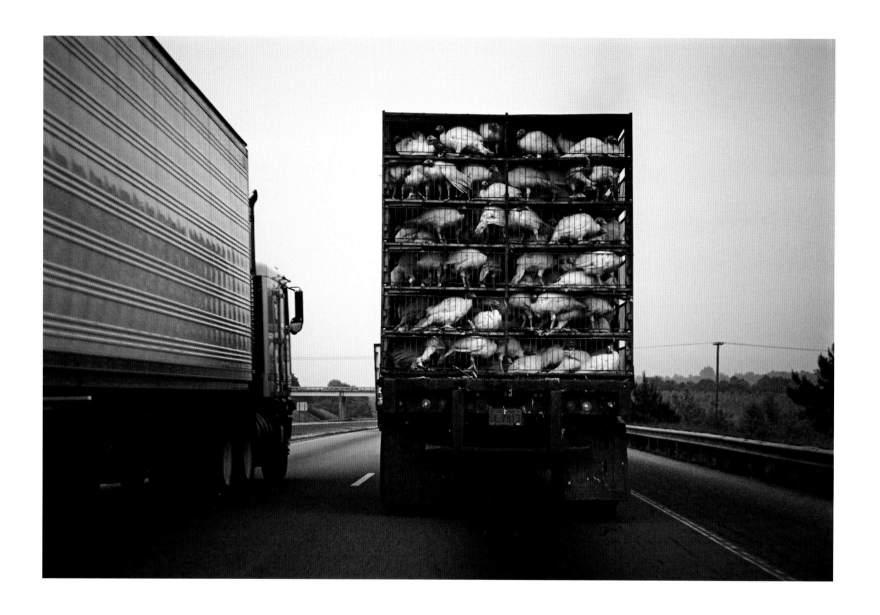

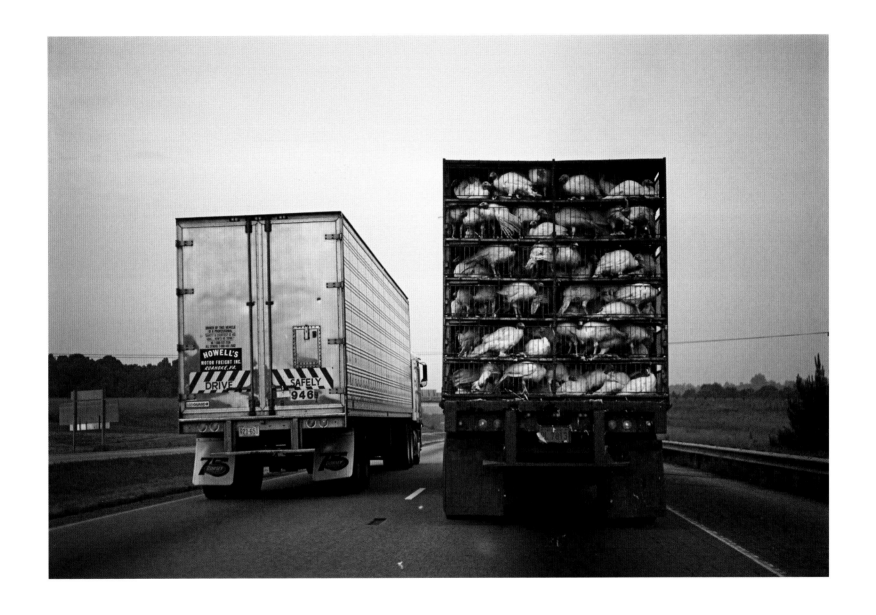

Two views of truck traffic, Interstate 85, South Carolina

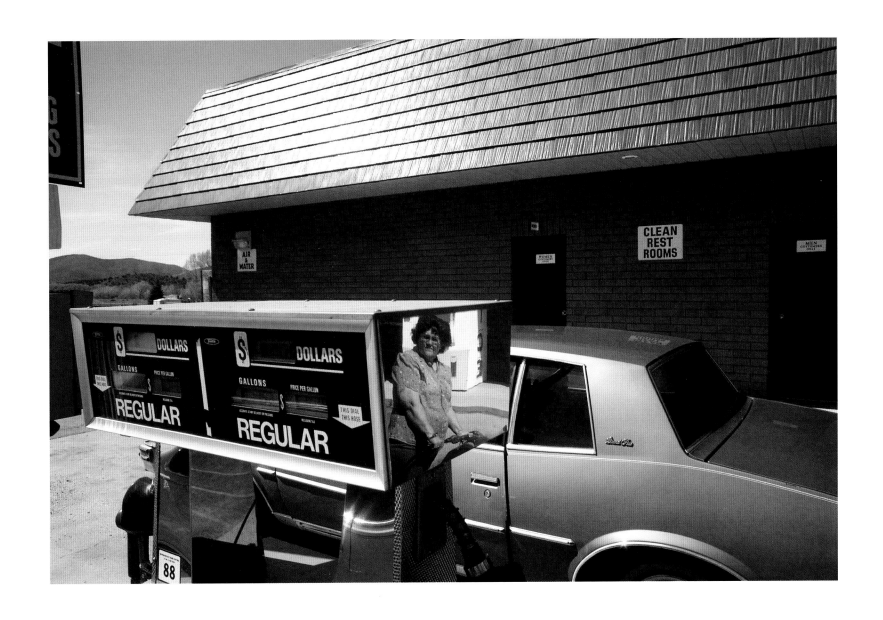

Near Kanab, Utah

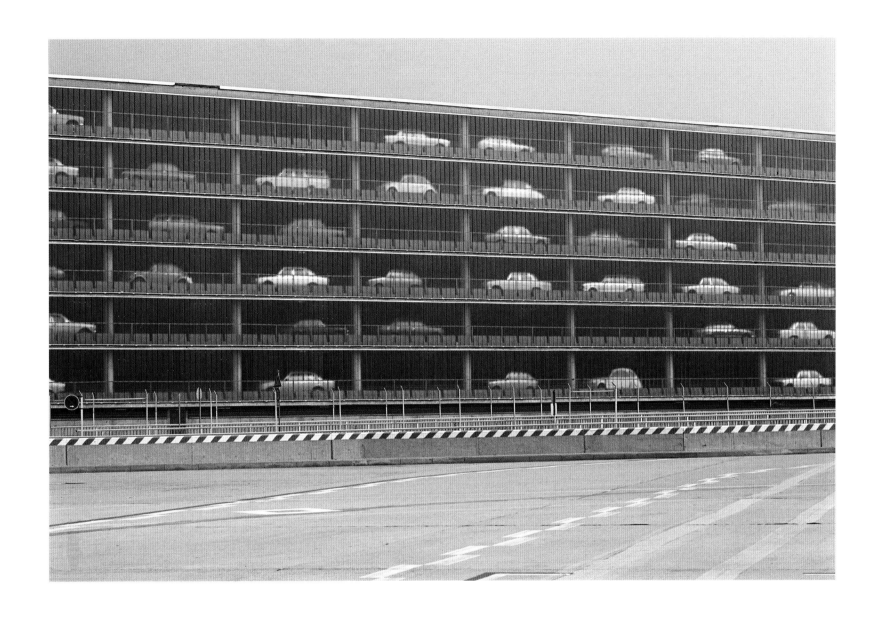

FRANKFURT AIRPORT, GERMANY

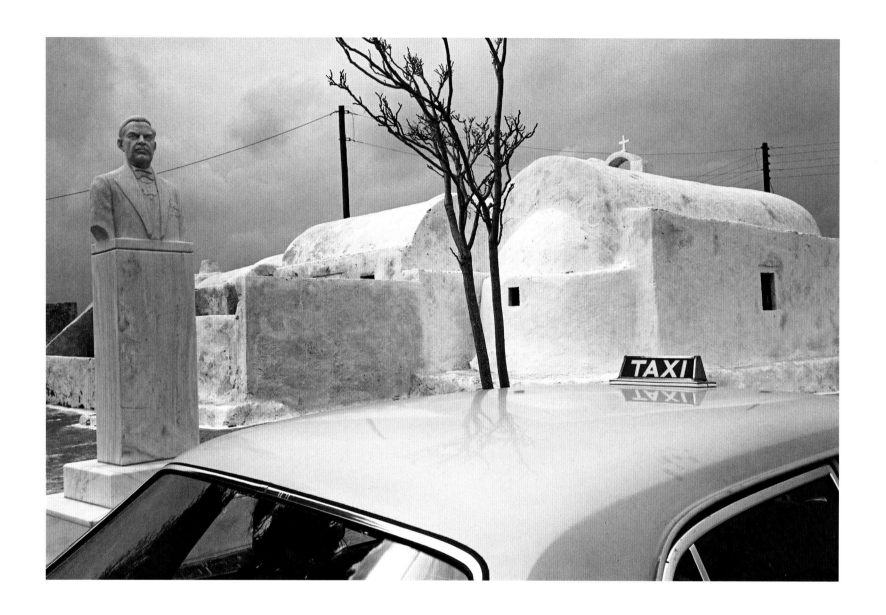

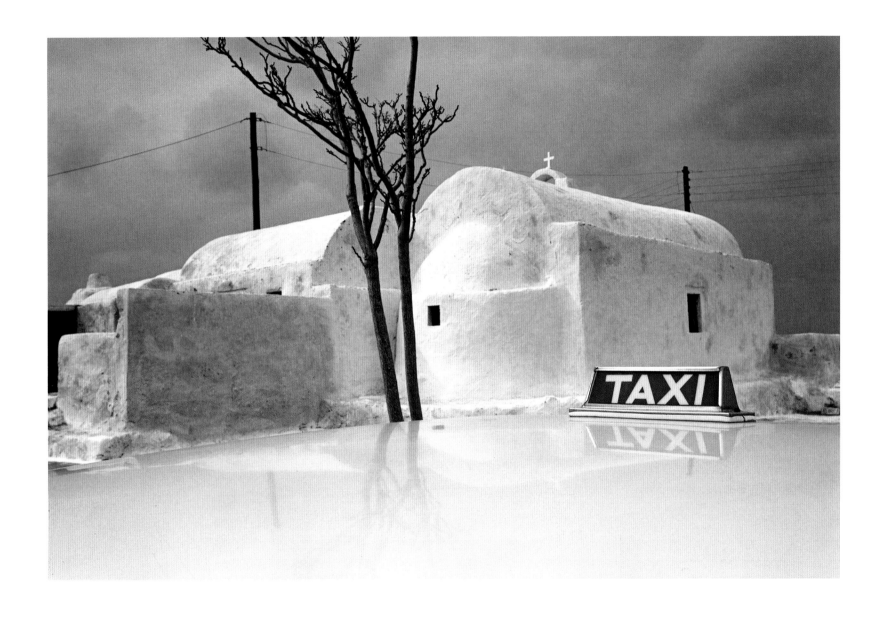

Two views of a street scene, Island of Santorini, Greece

I've seen only one dramatic event on the road and this is it. It's a train derailing. Up the track the cars have already begun to topple. If that continues the taxicab will be crushed and covered in corn. But that didn't happen. Somehow the cars stabilized and stopped toppling just before reaching the crossing.

The photograph is noteworthy to me for two reasons. First for what it omits—the excruciating, dangerous sound of metal against wood and rock. Second, because it's the only photograph in this book taken and not made.

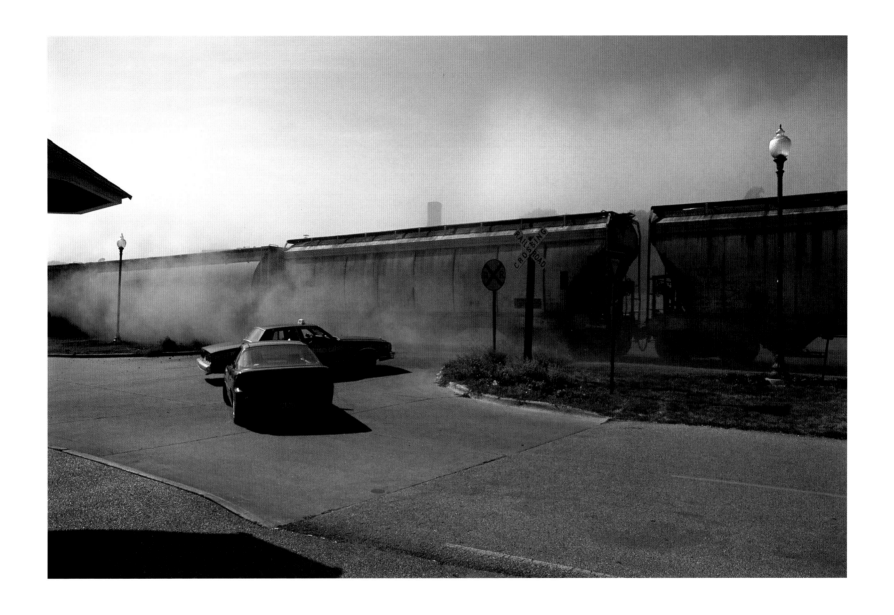

DAVENPORT, IOWA

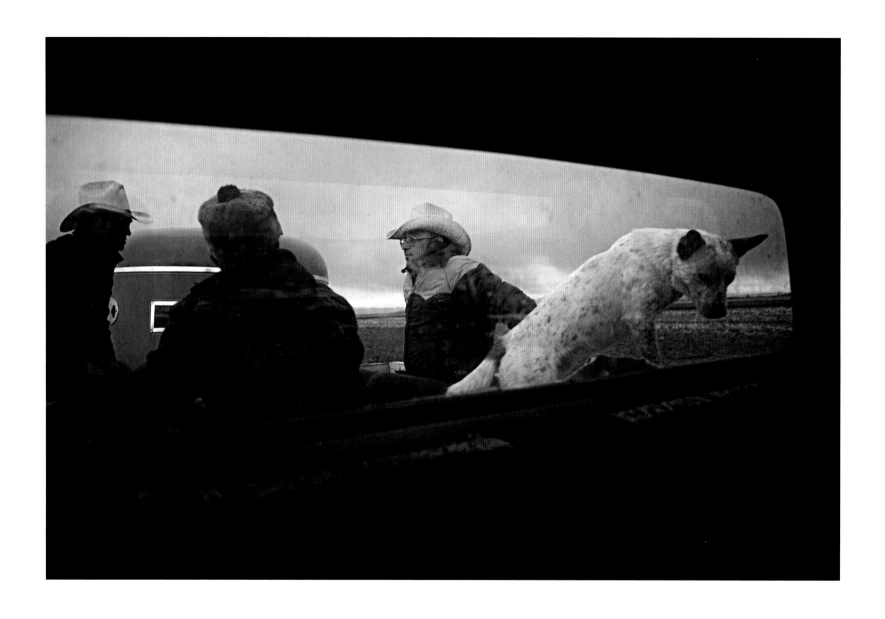

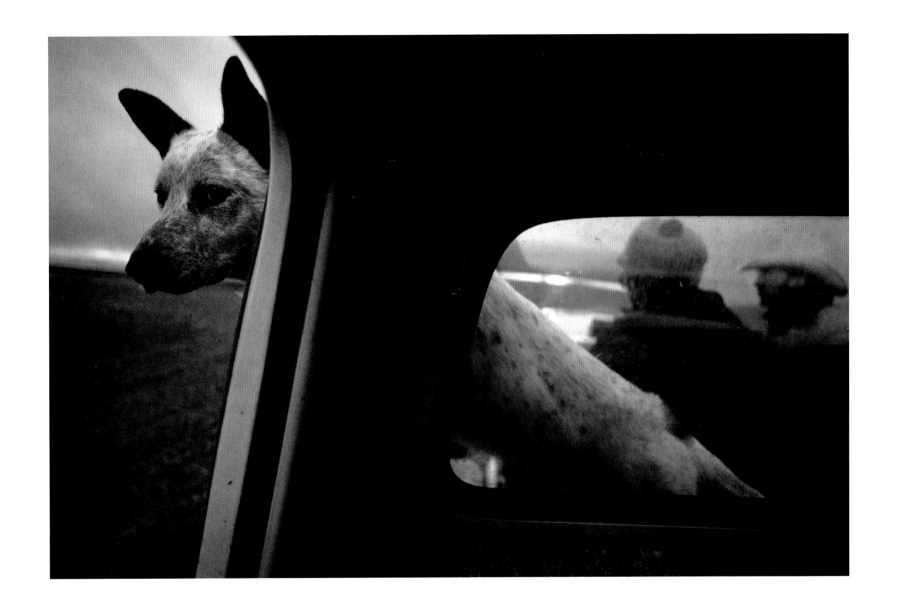

TWO VIEWS OF HUGO TUREK'S DOG, SQUARE BUTTE, MONTANA

"LET'S TAKE A SHORT CUT. If we cross the salt flats at low tide we can cut off sixty kilometers and get to Derby before dark," said Mike Osborne, my dependable guide in northwest Australia. Off we went, two fully loaded vehicles cutting smooth tracks in the still-moist salt flat. Everything went fine at first. Then I noticed Mike's tires were kicking out mud. I watched him struggle forward then veer left looking for solid ground. But he bogged. At the same time I felt the grip of mud on my own tires and steered right. But I too bogged.

Bogging anywhere in the outback is inconvenient but here on the salt flats with the tide coming in it would be extremely serious. The tidal flats of Northern Australia are littered with the rusted hulks of vehicles just like ours that had to be abandoned to the oncoming ocean.

"Now what?" I shouted to Mike. "Try backing up your own tire tracks!" Mike carefully did just that and I followed his example. Safely back on solid ground I looked at where we'd been and saw a photographic possibility, got out a tripod and made this picture from the roof of my vehicle.

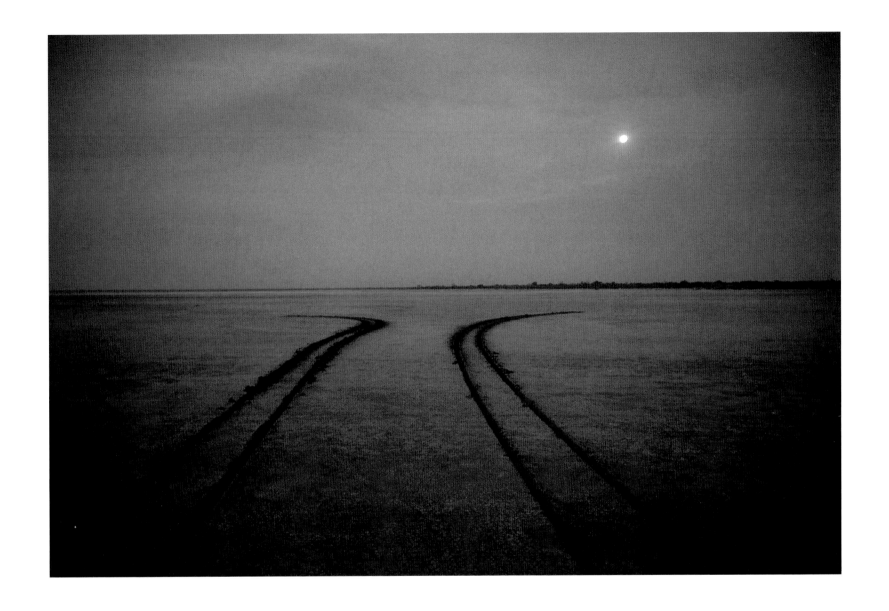

Tidal Flats, the Kimberley, Western Australia

PORTRAITS

FOR A PORTRAIT TO LAST FOR ME it needs to be part of a larger picture. The look on someone's face is important but only as an element of a more complex composition. In that way portraits are like other forms of my photography where gesture, light, color and space mingle and occasionally merge.

The preoccupied expression on the face of the station hand matters. But so do his hands, shirt and cigarette, the blue sky and late light. However, it's the sky-filling flock of cockatoos that finishes the photograph and sets the scene in Australia.

Still, these are portraits of people, and with that comes an expectation of emotion. But absence of apparent emotion is also involving. The young man in the diner, the famous artist in his home, the Japanese youth being made up for a Shinto festival—what are their moods? They are neither happy nor sad but are emotionally within themselves.

It is the same for the other photographs of people that have lasted. Their moods are not easily memorized. Questions linger over their faces and give life to their portraits.

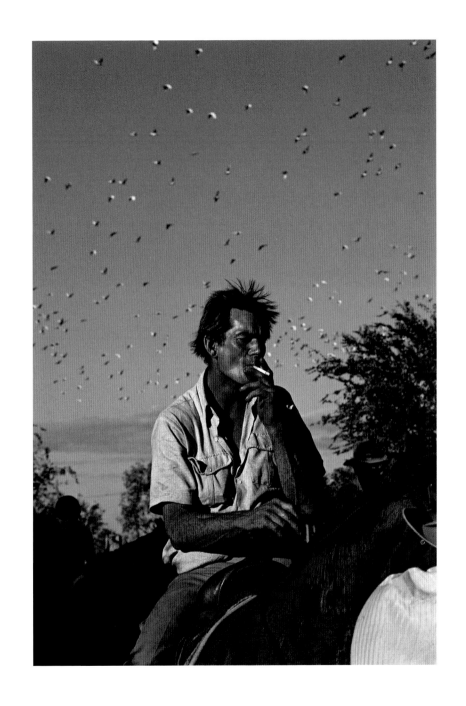

STATION HAND, DERBY RODEO, THE KIMBERLEY, WESTERN AUSTRALIA

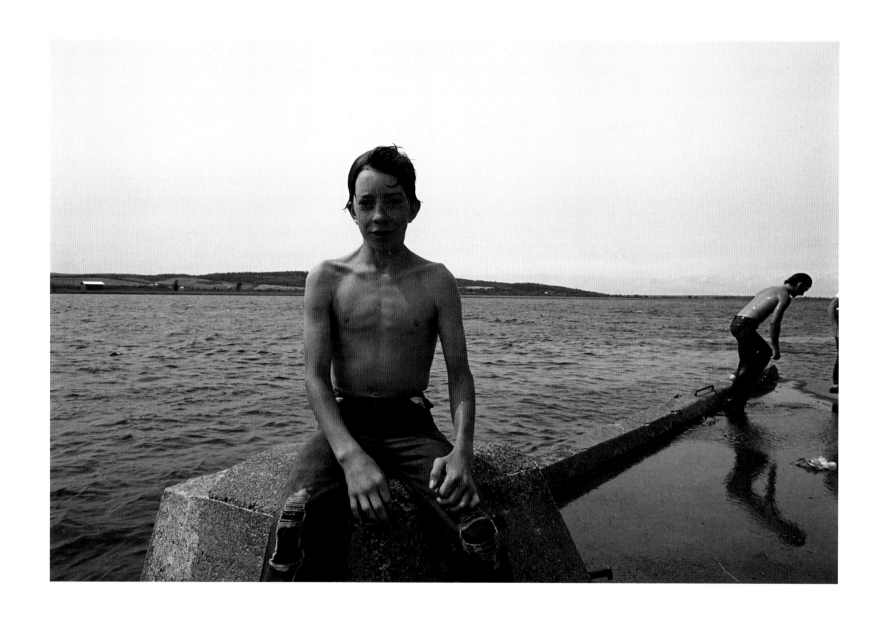

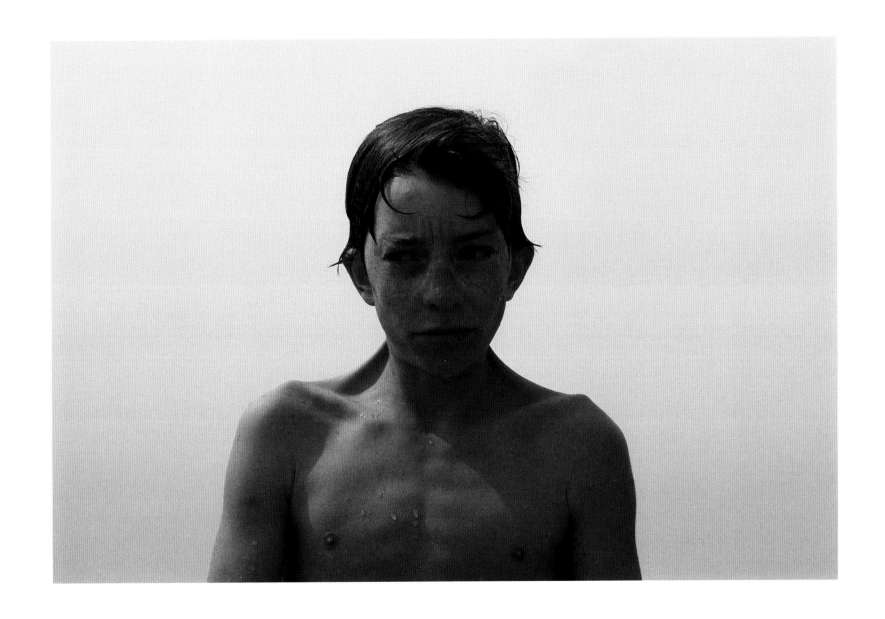

Two portraits of a swimmer, Nova Scotia

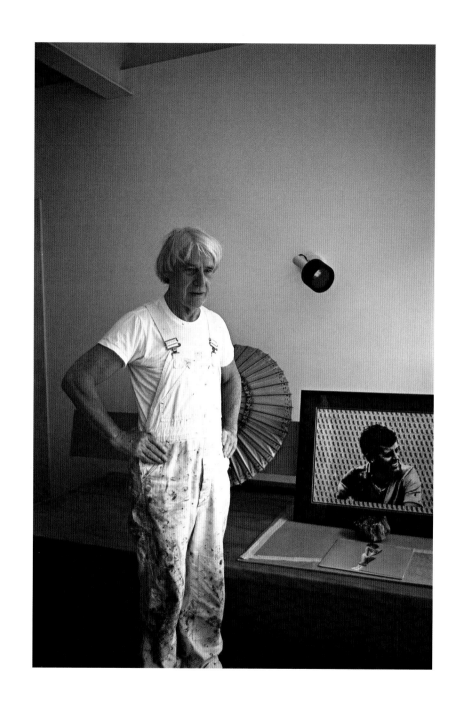

WILLEM DE KOONING, SPRINGS, NEW YORK

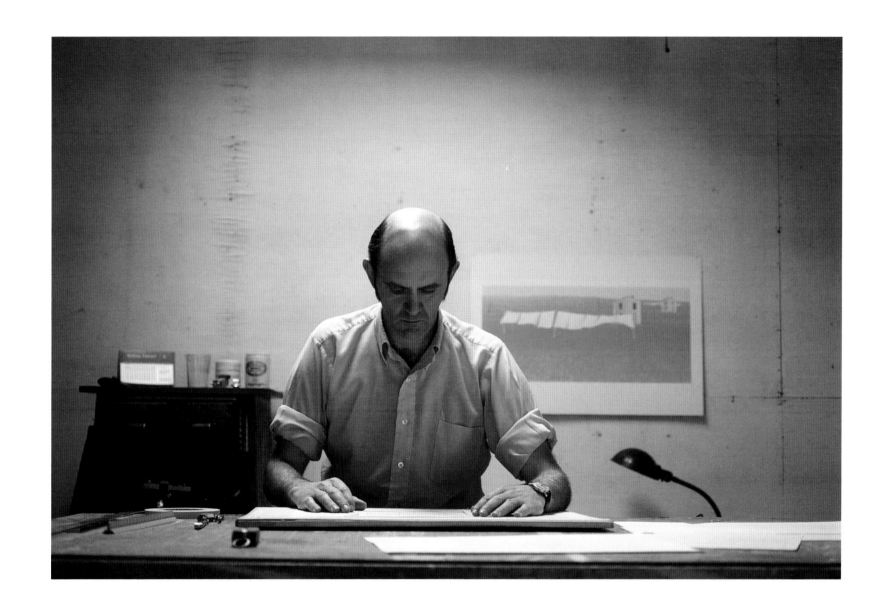

CHRISTOPHER PRATT, SALMONIER, NEWFOUNDLAND

This photograph began as a straightforward portrait of John Fraser. I was intent on expressing the mood of a man preoccupied with the difficulty of running a vast cattle station in an almost arid landscape. At this moment the station was blazing with an unstoppable bush fire (pages 108 and 109). As he thought about this he tapped his lighter against the tin of tobacco on the table.

I was thinking about how to fit him into the other elements of the composition. I was particularly looking at the shape of the space between the back of his head and the curve of the bedstead.

Just then his granddaughter came into the picture and, oblivious to us, grasped the bedstead and ran her foot up the wall to touch the circular edge of the mounted horns. I made a photograph when her toe made the touch but her effort looked strained. The next picture, this one, has a relaxed and graceful aspect, which is what I was after.

Her appearance gave me a chance to express two states of being—John's worry for the survival of his station and Amanda's dreamy days in the Australian outback on that same station.

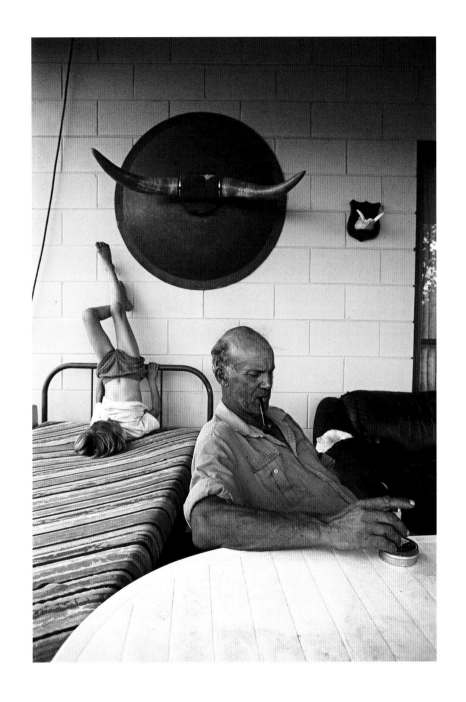

Strathburn Station, Cape York Peninsula, Australia

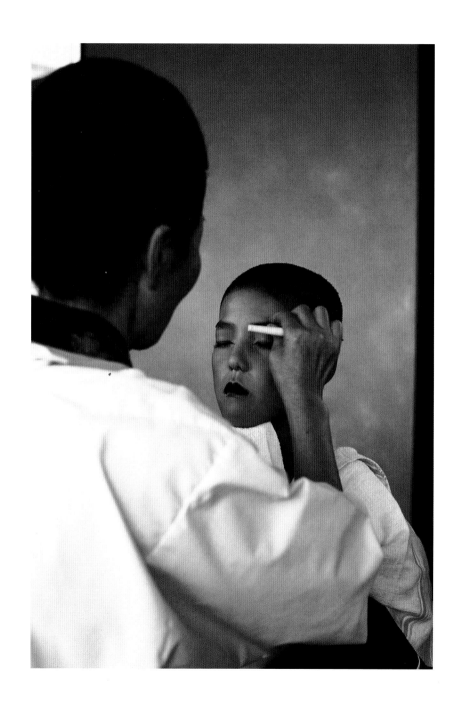

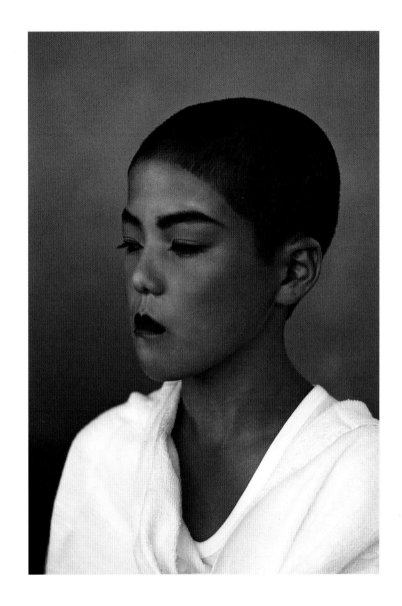

TWO PORTRAITS BACKSTAGE BEFORE A SHINTO CEREMONY, HAGI, JAPAN

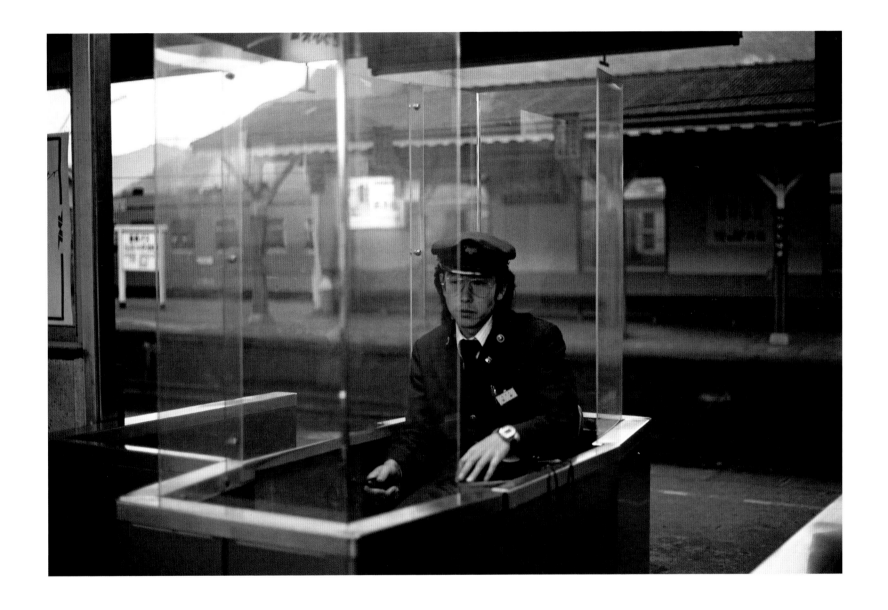

Ticket taker, Central Railway Station, Hagi, Japan

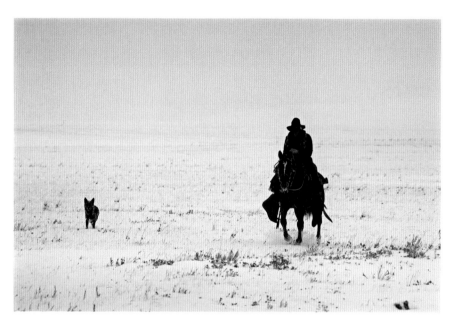 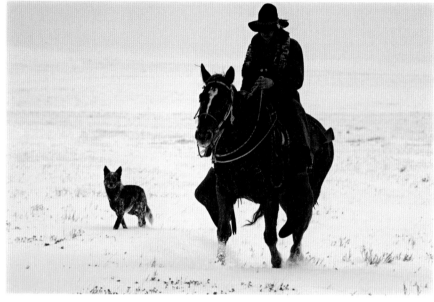

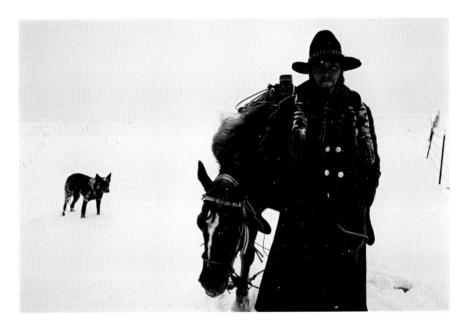 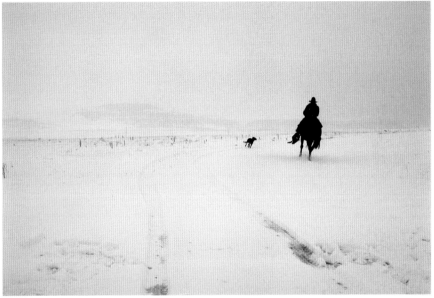

The approach and departure of Gerald Mack, Little Belt Mountains, Montana

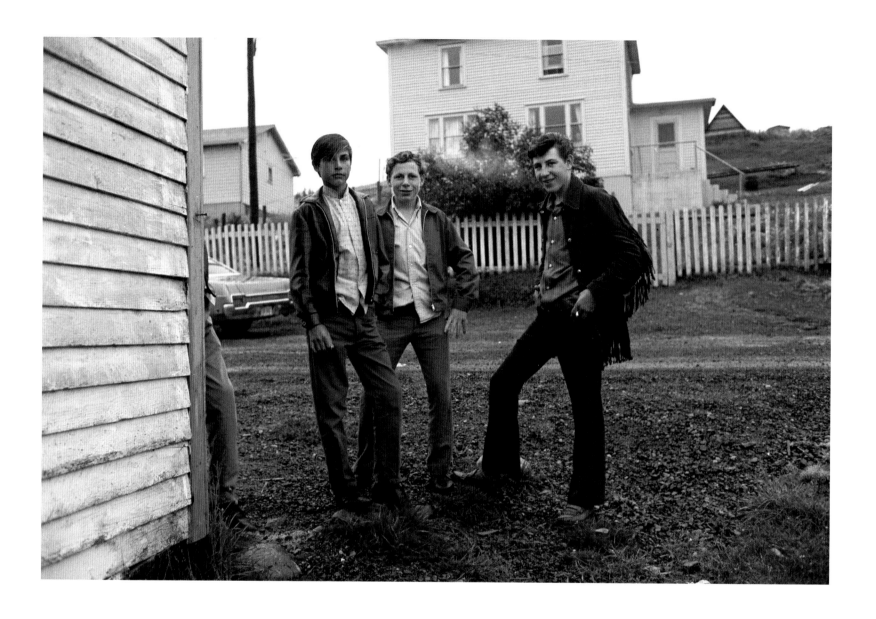

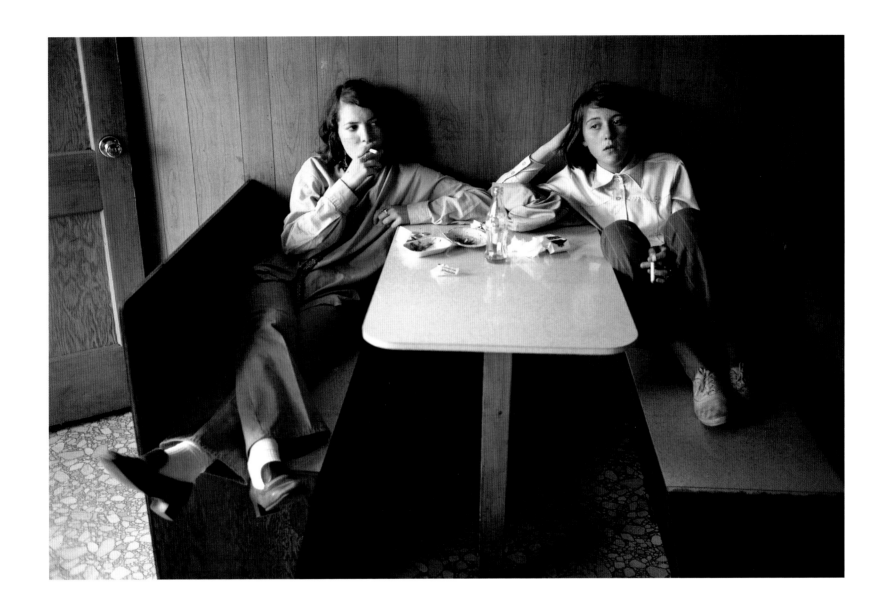

NEWFOUNDLAND, CANADA

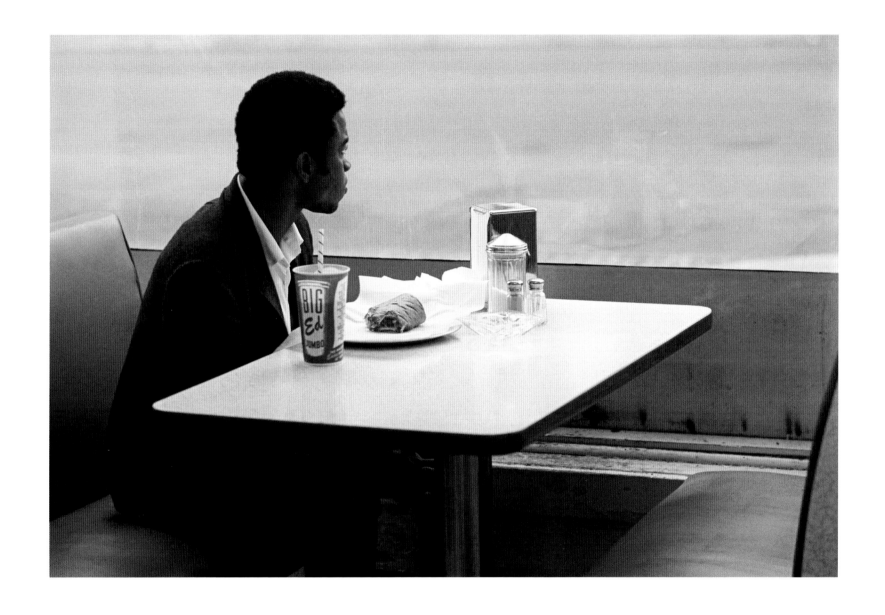

Eddie Leonard's Sandwich Shop, 17th & M Streets, Washington, D.C.

Portrait of a People

The Aborigines are calling the dancers. One elder is lightly tapping a stone. The others are chanting. In a moment the song will be returned, then the dancers will emerge from the forest, gather smoking sticks from the fire and dance the dance of creation.

But this long moment, quietly charged with expectations, cast its own spell. Now I had to call on something special myself—photography's suggestive power. I took a stance behind the elders. From there they could be respectfully seen in a characteristic setting—together on their land and in their language.

Aborigines lived alone in Australia for eighty thousand years until Englishmen arrived and legally proclaimed the land to be uninhabited. The destructive results of this cultural collision were one-sided, profound and persistent. One consequence was that it drove Aborigines together. They are a nation within a nation, knit together by kinship, language and land.

Who they are and who they are not was unknown to me when I began working in northern Australia. It still is. One reason is that Aborigines were understandably wary of me. I was a white fella and, noticeably, a photographer. But so too were my Australian friends Mike Osborne and Kerry Trapnell. And they were respected, even beloved, in the Aboriginal communities where they worked. Because of them I was also allowed to work.

It wasn't always easy. Aboriginal time is different from photographer time. The hunt scheduled for dawn gets underway at noon. Often things don't take place at all. But then, spontaneously, something unpredictable happens. A truck bogs on the beach, a horse is injured, a fire is lit, a story told, a song sung.

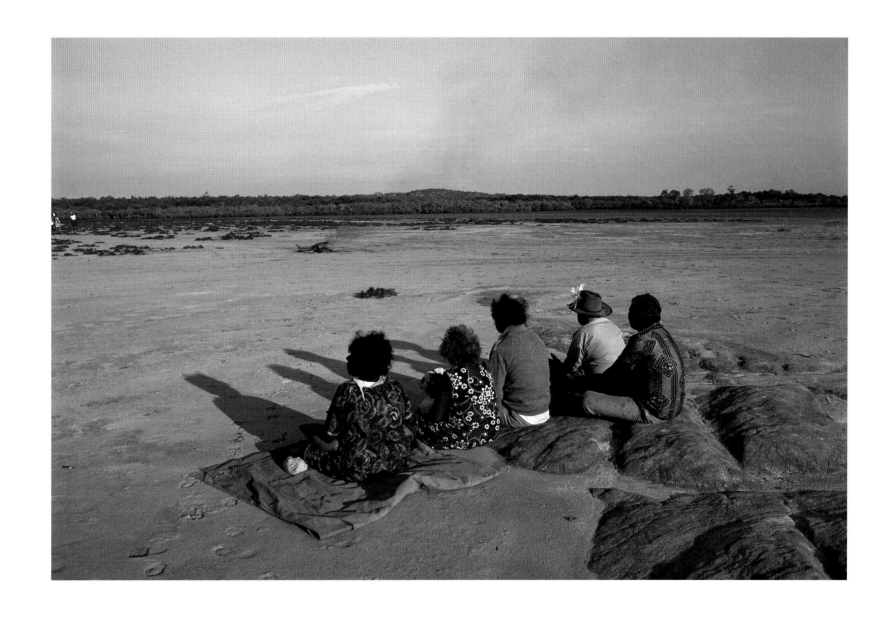

KALUMBURU, THE KIMBERLEY, WESTERN AUSTRALIA

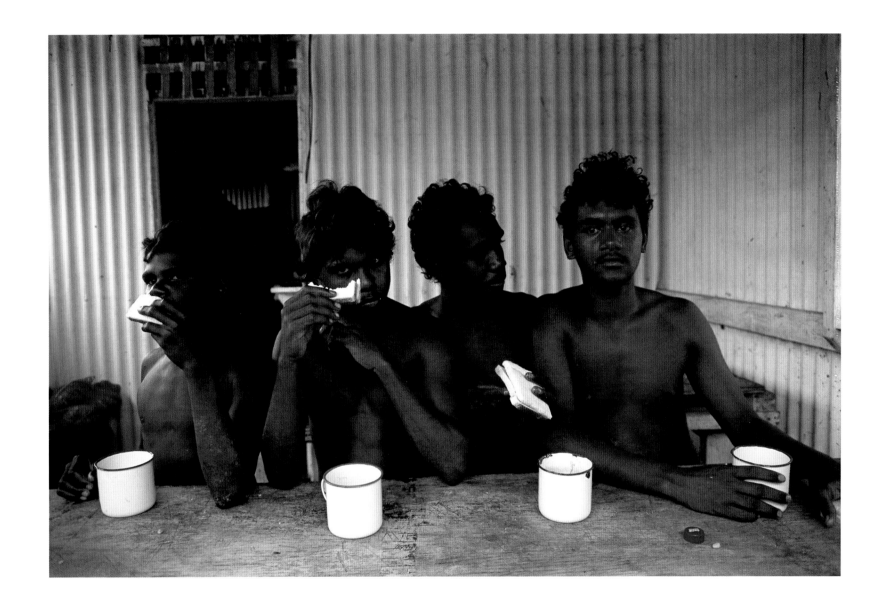

STRATHBURN STATION, CAPE YORK PENINSULA, QUEENSLAND

A YOUNG ABORIGINE NICKNAMED DIXIE cradles the head of his wounded horse in this photograph made in the last light of day on a cattle station in the remote bush. The episode had unfolded before I arrived on the scene but it wasn't hard to reconstruct what had happened.

Dixie had spent the day rounding up wild bulls by horseback, an extremely tough, throwback way of cowboying that almost no one in Australia undertakes anymore. But this day had been a good one. He'd dogged several bulls to the ground and tied them to trees. In doing so he'd used all his stout rope. Then he'd come upon one last bull, chased it down, dogged it, and tied it to a tree with a weak tether. The bull had broken loose, gored the horse and charged off into the bush. After we arrived the wound was cleaned with canteen water and sewn with horsehair.

In the dark the horse was stood up and left. As we rode off I asked would the horse survive. The answer was "The horse knows the way back to the station. He will go there if he can. There's nothing else we can do."

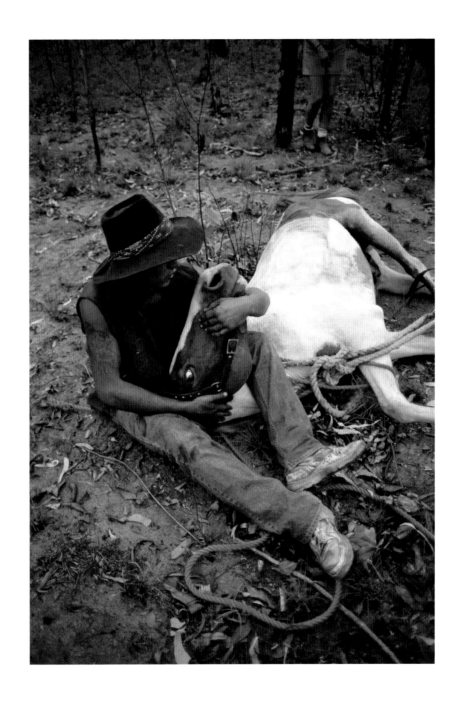

STRATHBURN STATION, CAPE YORK PENINSULA, QUEENSLAND

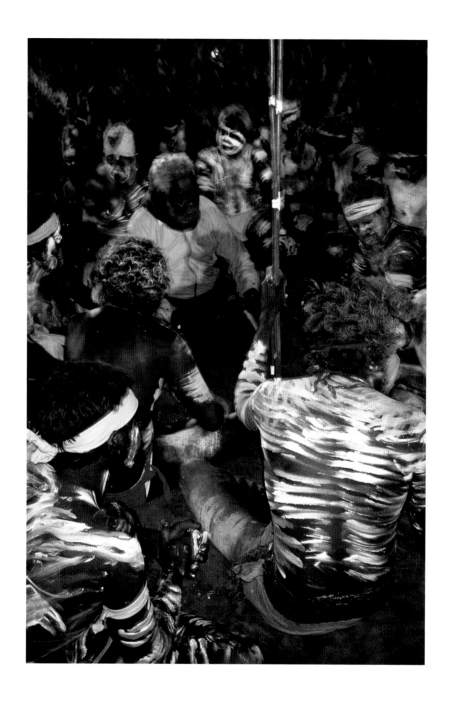

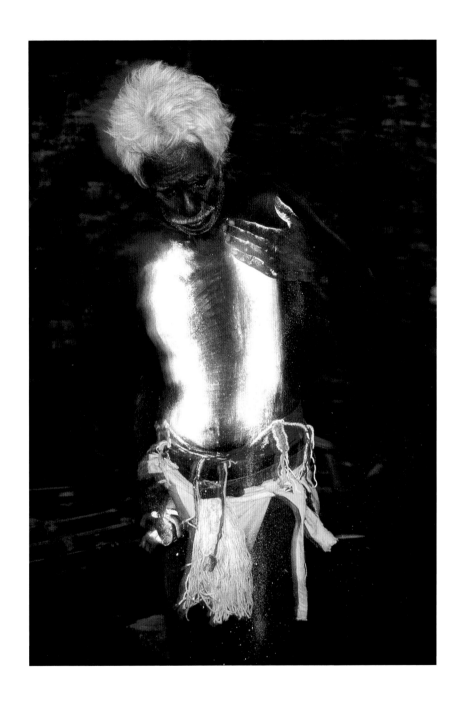

Two views of dancers preparing for a Coroboree, Derby,
the Kimberley, Western Australia

Balgo is an Aboriginal community on the northern edge of the Great Sandy Desert and the summer I was there it was closed to outsiders. There was unrest. But that didn't stop my guide Mike Osborne from going there. He was known and respected in the community and on the strength of that we went.

Our purpose was to photograph the unique Balgo Hills (pages 112 and 113). On our way we stopped to pay respect to Mike's friends and took in a soccer game. I made a few photographs of the game because the men were fearlessly playing barefoot on rough gravel.

After the game I made this photograph of a departing truck of Aborigines. It struck me how characteristic the scene was. Aborigines travel together.

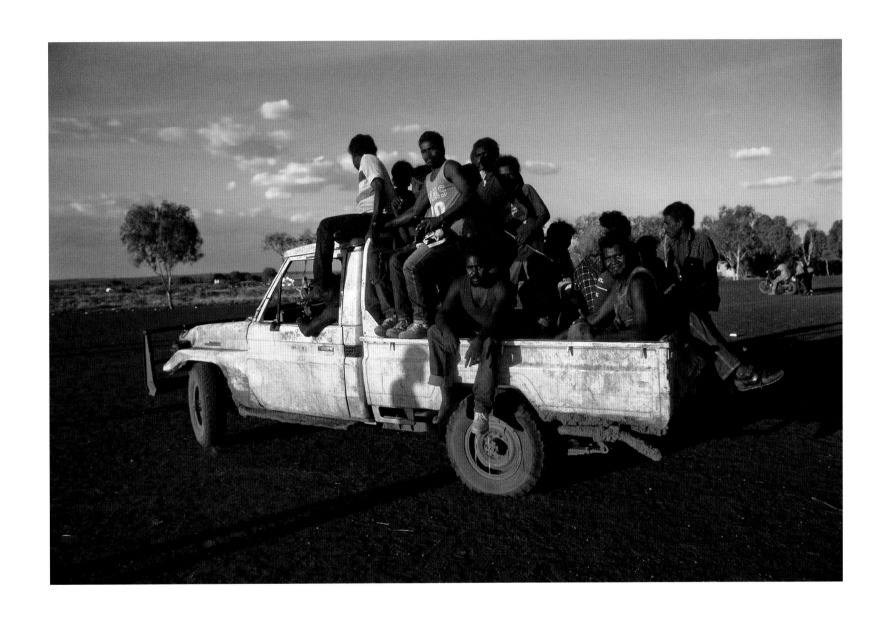

BALGO, GREAT SANDY DESERT

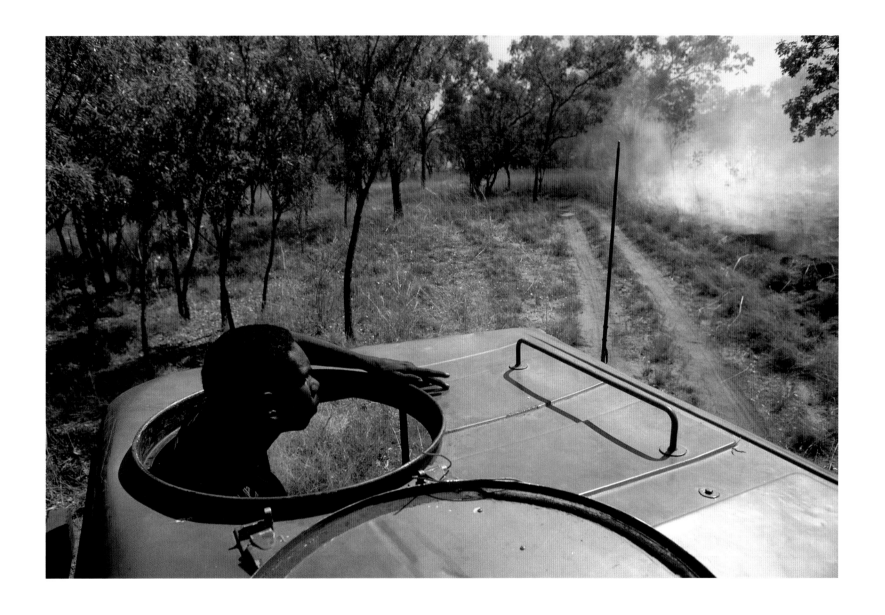

THE KIMBERLEY, WESTERN AUSTRALIA

Mark Mora is sitting in the shade telling a story. Both the shade and the story are significant. Aborigines have an instinct for the shade—where it is, where it will be and how to stay in it. Sometimes the desert light was so bright I couldn't see them in the shade, to say nothing of making a photograph in the stunning contrast.

The story was significant because it wasn't easy for me to converse with Aborigines in the communities. But we were on a hunting trip and it had been successful (pages 94 and 95). Now at lunch Mark was remembering the great hunters he had known. The greatest of all was his uncle who had been so tall and strong he could hold a kangaroo off the ground with one hand.

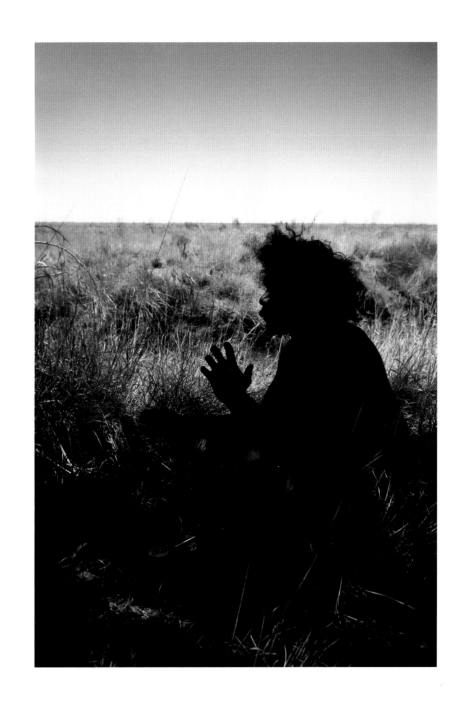

MARK MORA, GREAT SANDY DESERT

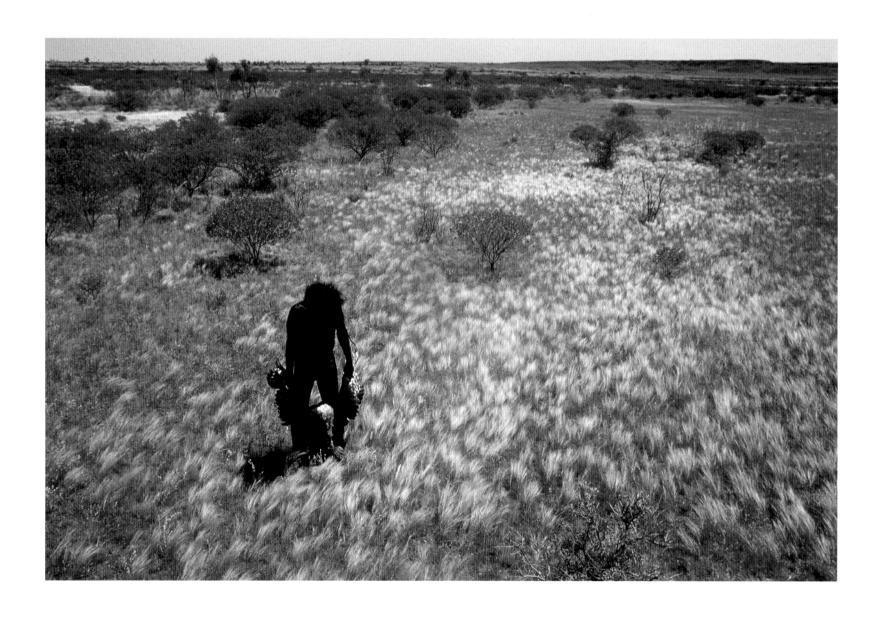

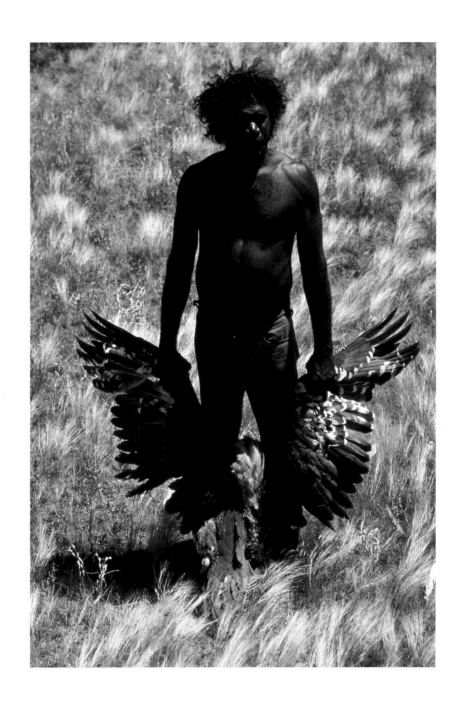

Two views of Mark Mora with a Bush Turkey, Great Sandy Desert

Is there such a thing as a complete photograph where all the elements that matter to me are present? If so, this would be that photograph. It's in color but barely. It's documentary realism but slightly surreal. The composition is rigorous but flowing and the light is dazzling.

So I would like this photograph even if there wasn't a dire drama unfolding at the center of it. But there is. Aborigines have accidentally bogged their pickup truck in the sand and can't get it out. They are miles from their community and the tide is coming in.

While we circle them for photographs the pilot radios for help. We fly off for more photography and return an hour later to see that they are being pulled to safety.

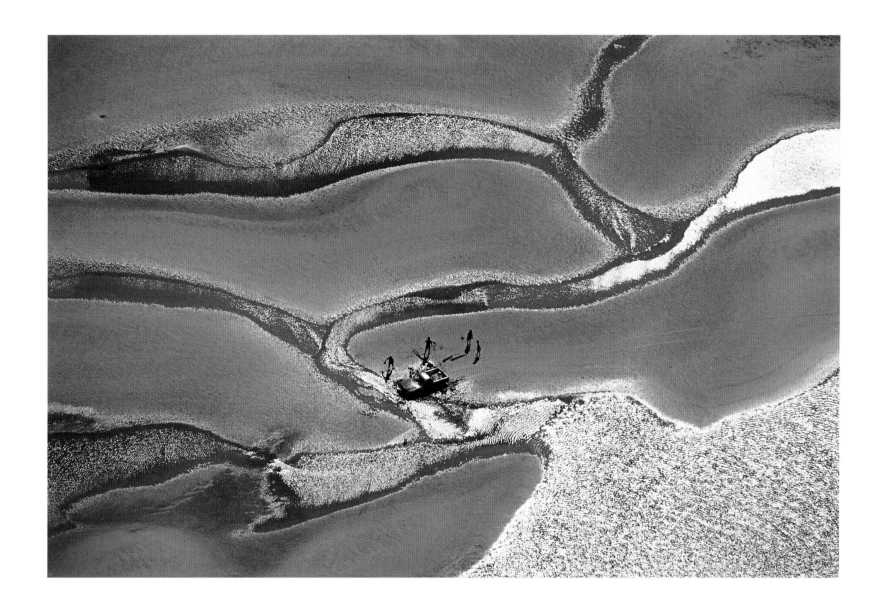

Near Lockhardt River, Cape York Peninsula, Queensland

LAND SEA SKY

I AWOKE THIS MORNING TO FIND THE HORIZON MISSING. The dependable line that defined my photography was gone. In its place was a monochromatic watercolor of merged sky and sea. Within this seamless atmosphere the only straight line was the base of a distant island.

I settled the composition on that line and spoke to the captain. "What's the name of that island?"

"Isla Sin Nombre," he replied. "No Name Island."

That non-name fit well with my landscape photography. Almost every image I've made has been in an anonymous setting. What has interested me about these landforms has been their structure and also the moment they were in. These landscapes were in motion—the fog was lifting, the storm lowering, the moon rising, and the fire burning through. Because of that I've often had to work quickly so it hasn't always been contemplative. But that is the feeling I want in my finished photographs.

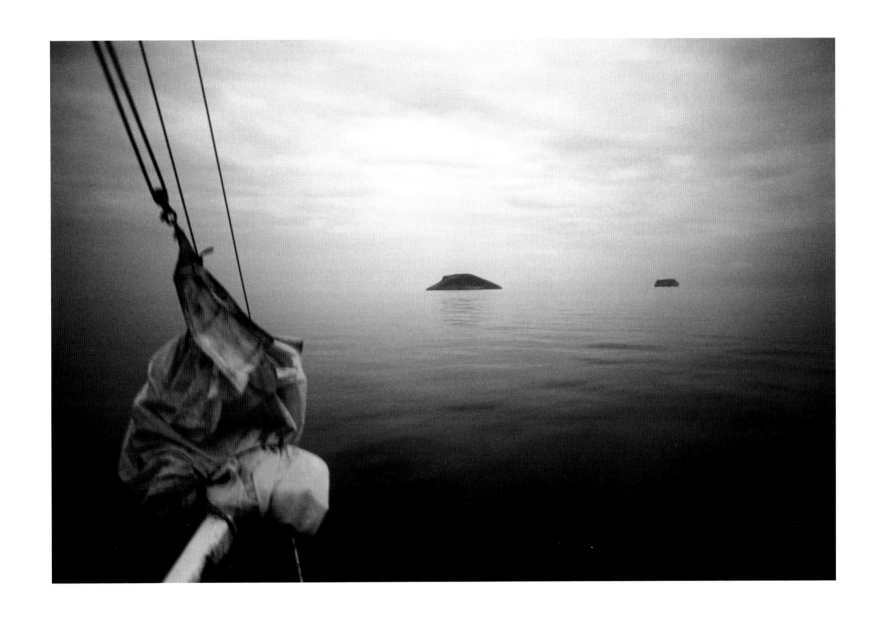

GALAPAGOS ISLANDS

THERE WAS AN UNEXPECTED BLEND OF POWER AND POETICS to being on top of this nameless knoll in the far northwest of Canada. From it one could see everything in all directions. Almost every Arctic predator had a den, borough or nest on it. They too could see anything that was coming.

What was coming at me this day was an elegant storm that stood in the sky in silent layers of gray and white. The photographs on pages 102 and 103 are of that storm's approach. Below the storm in the bank of the Firth River a crevice holds a last remnant of snow.

I stayed as long as I could then hurried off the knoll to secure my tent. From there I looked back and photographed the now-dark sculpture of the knoll as the storm overtook it.

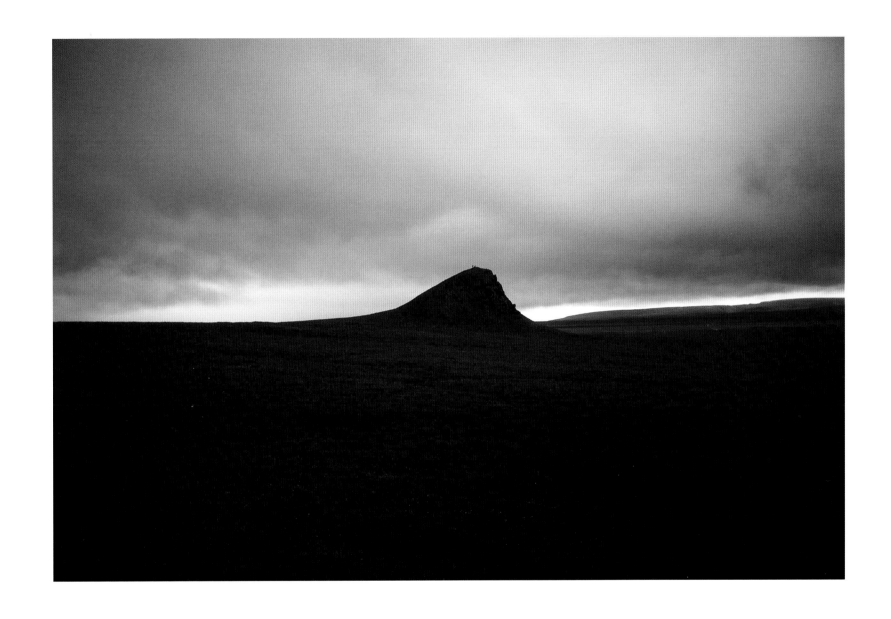

Arctic Plain near Firth River, Yukon Territory, Canada

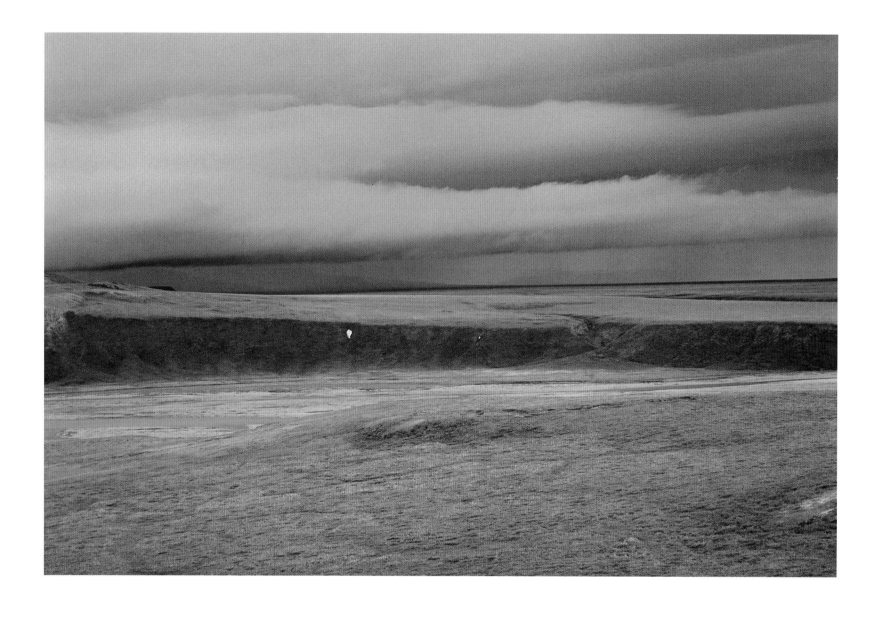

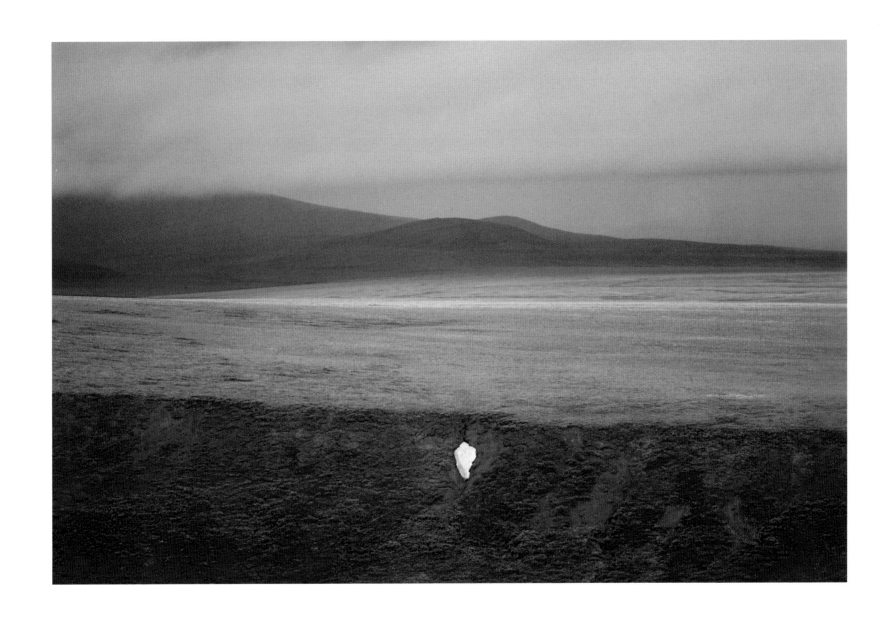

TWO VIEWS OF AN APPROACHING STORM, FIRTH RIVER VALLEY,
YUKON TERRITORY, CANADA

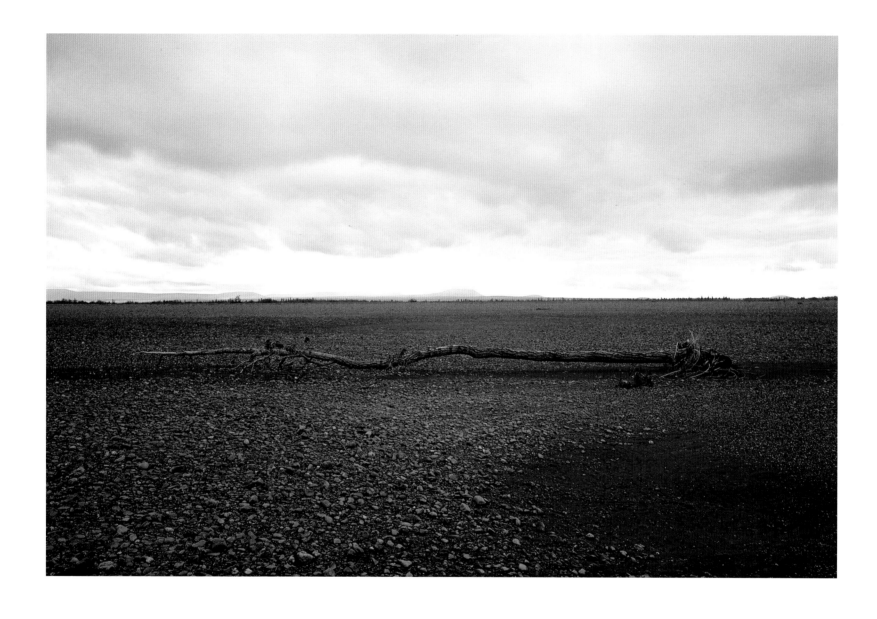

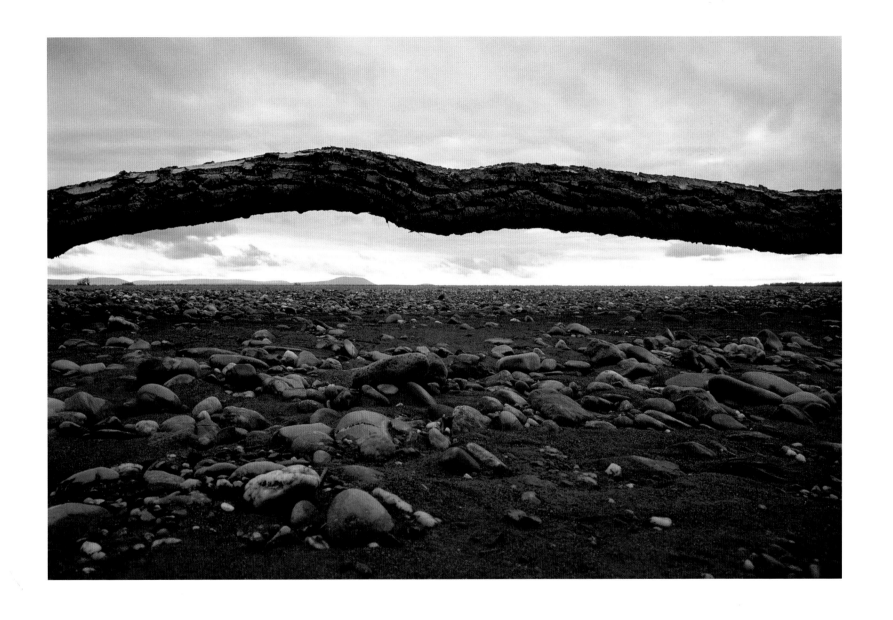

Two views of a fallen tree, Noatak River delta, Alaska

I SPENT THE SUMMER I WAS SEVENTEEN working at a summer camp in Michigan and often roamed the quiet woods at night after work. One night there was fog in the forest and a full moon. The moon cast shadows of the conifers onto the fog. I'd never seen that before and thought I'd never see it again.

I saw it once more, though, and made a picture of the effect. This time the shadow of the tree fell on warm mist rising from a thermal spring. When a breeze blew the mist, the shadow of the tree mysteriously moved. Sometimes the projected image disappeared entirely, only to reappear when the breeze diminished and the mist reformed.

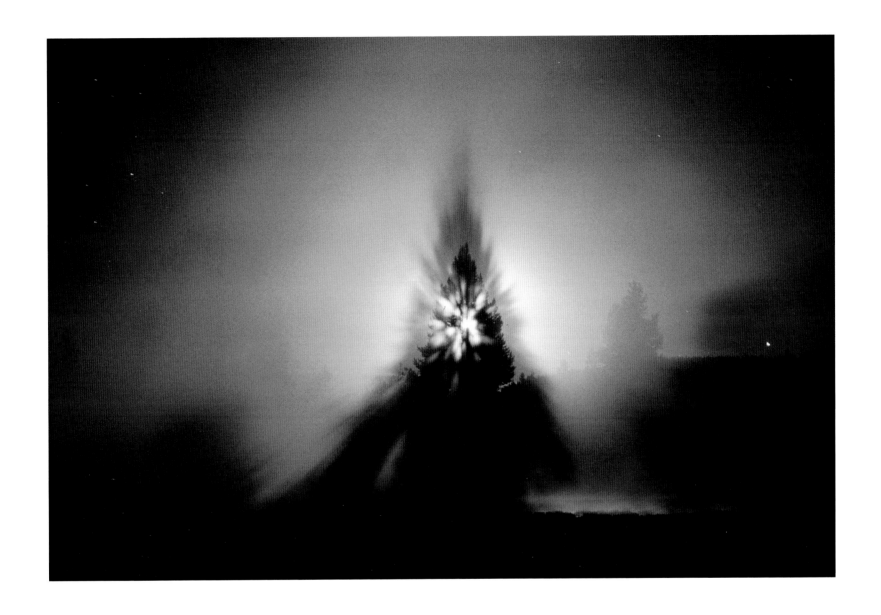

Moonrise, Biscuit Basin, Yellowstone Park, Wyoming

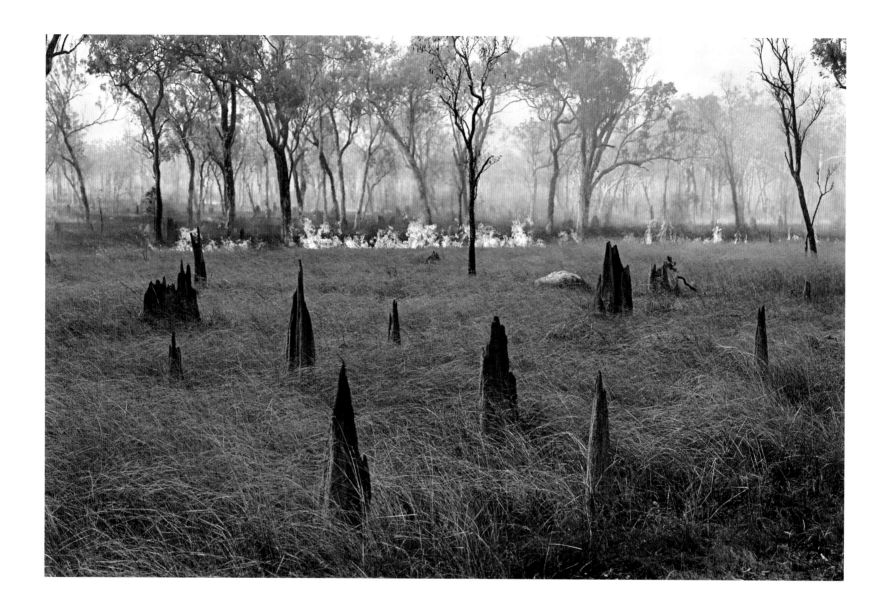

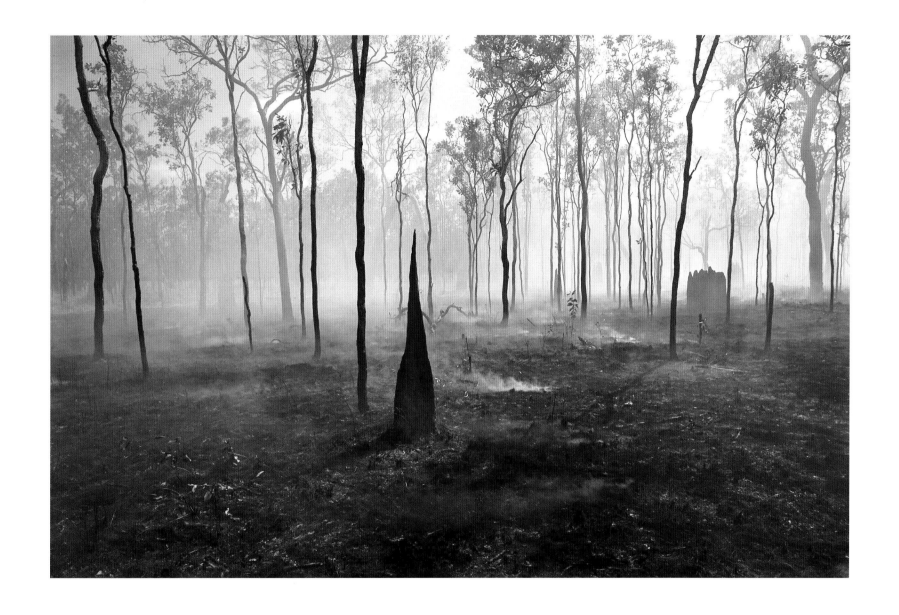

Approach and aftermath of a bushfire in a landscape of termite towers and gum trees, Strathburn Station, Cape York Peninsula, Queensland, Australia

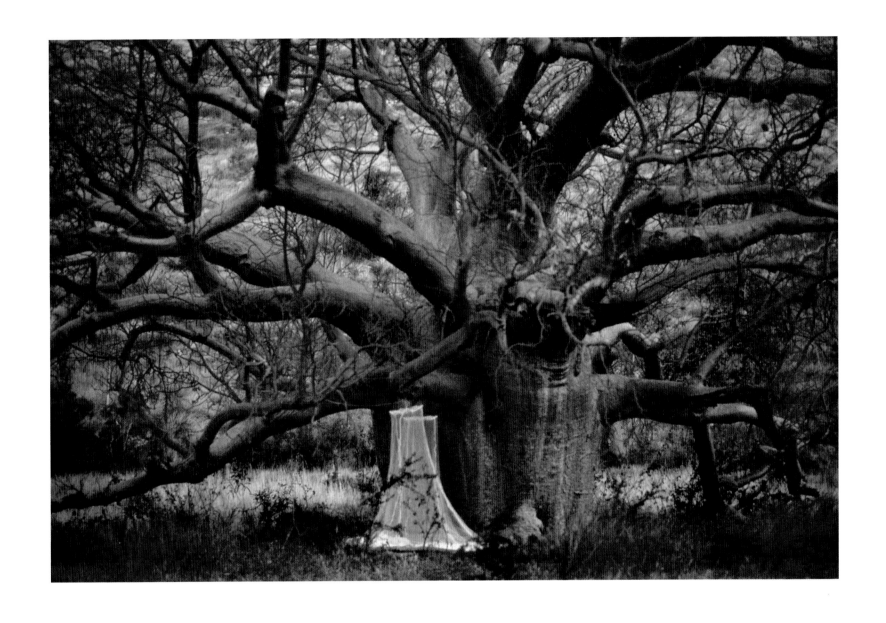

BOAB TREE WITH MOSQUITO NETTING AND SWAGS,
THE KIMBERLEY, WESTERN AUSTRALIA

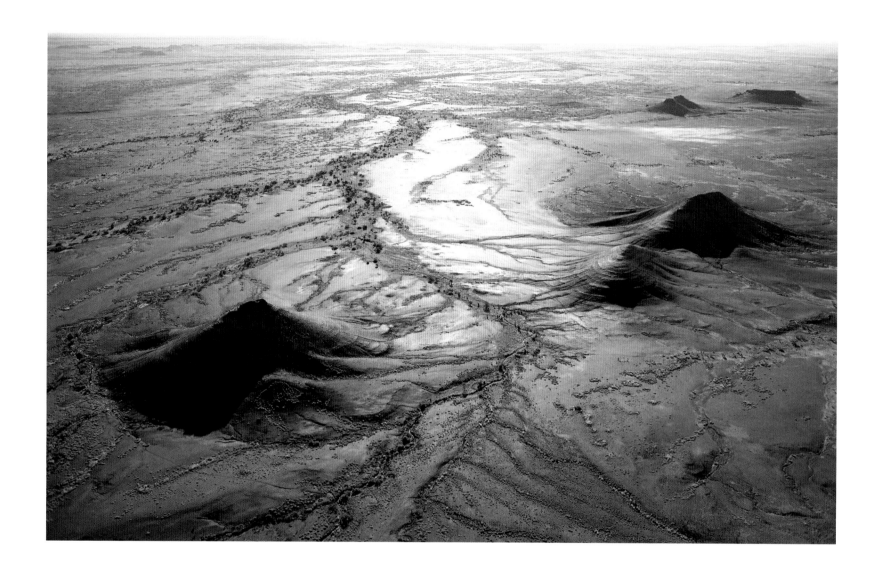

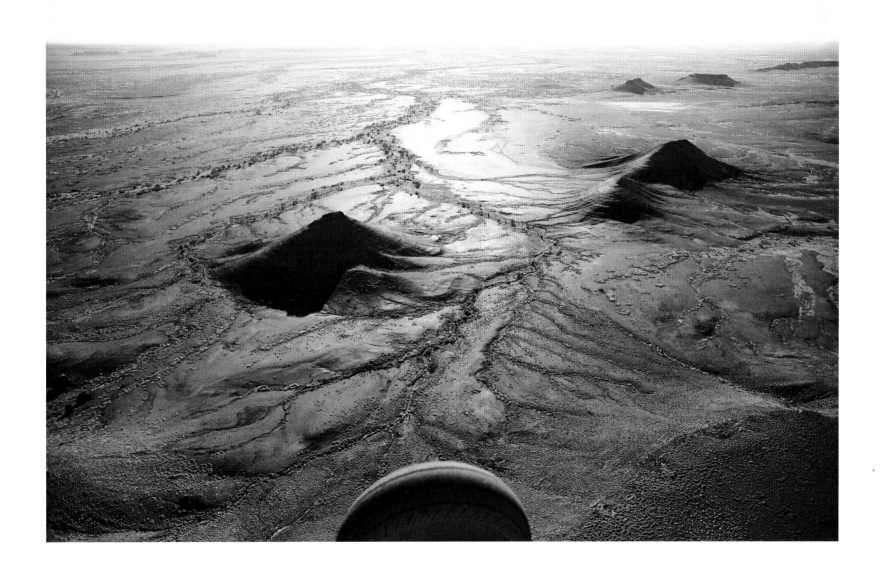

Two views of the Balgo Hills, Great Sandy Desert, Western Australia

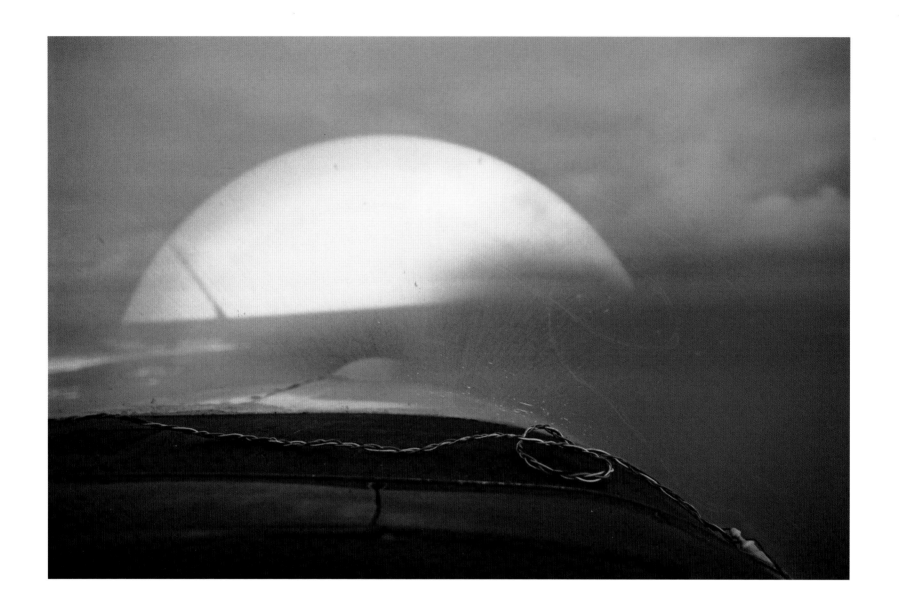

ABOVE THE SOUTHWEST COAST OF AUSTRALIA

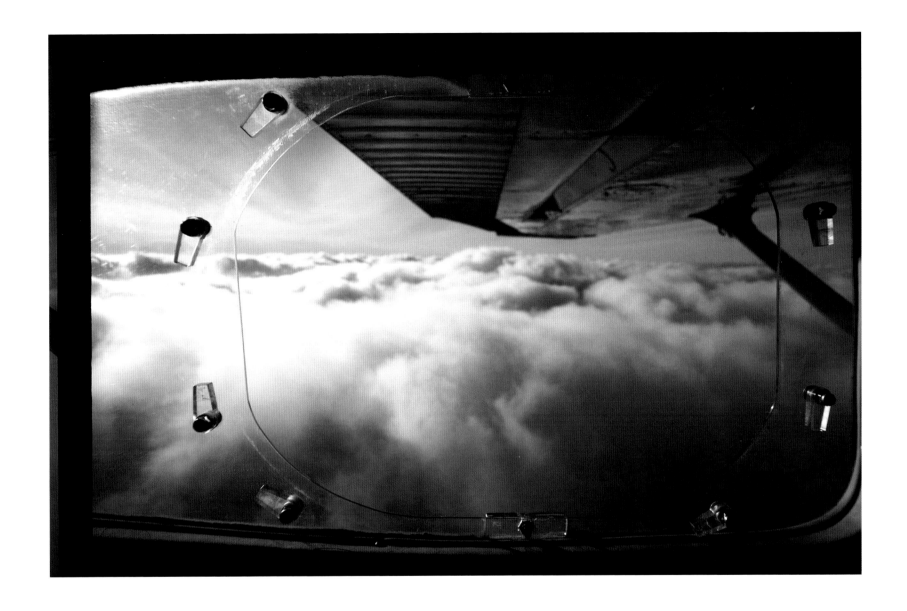

ABOVE THE SOUTHWEST COAST OF JAPAN

WILD LIFE

THE MONKEY WAS CURIOUS. It wanted a better look at me so it stood up. It was a photographic moment, but also a shared one, and that is what I wanted from wildlife encounters. So I approached animals as a person with a camera, not as a wildlife specialist. Consequently I have fewer photographs of wild animals but all of them represent close, occasionally sudden, encounters.

I also was interested in the evidence of animals—that a bird had walked by recently, stepped in mud, stepped on a rock, then stepped off. Or that a large animal lived here in a smooth dark hole in the ground. Or that whales had perished here and in their decay become part of the beach.

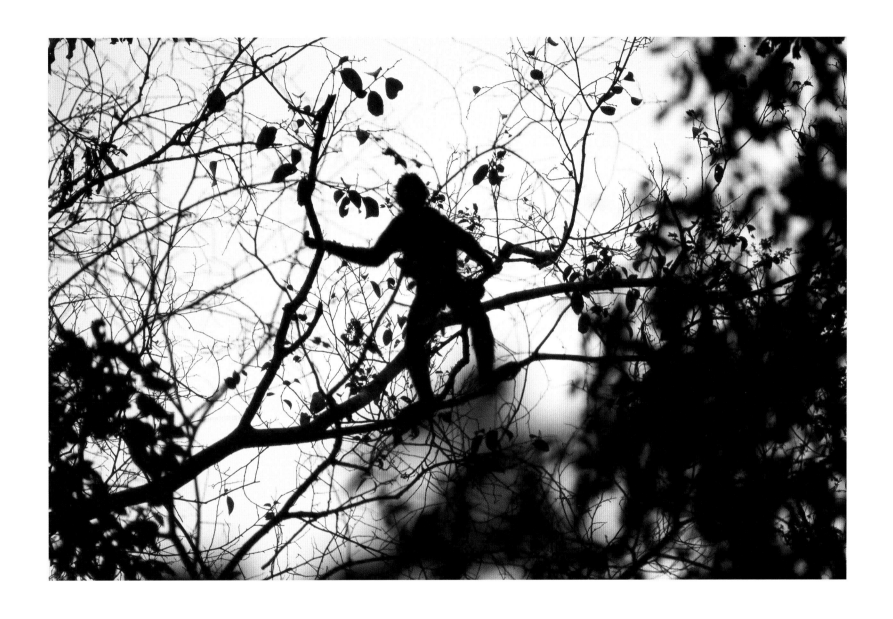

SPIDER MONKEY, HEATH RIVER, PERU

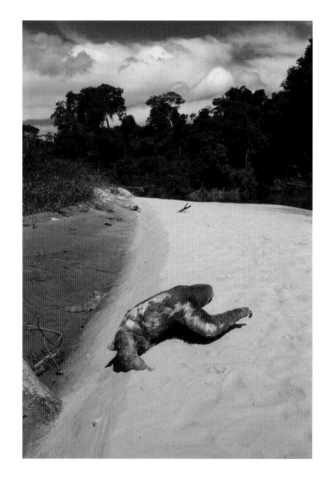
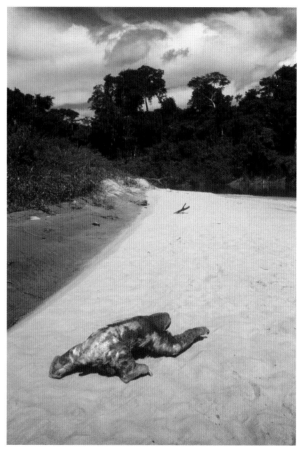

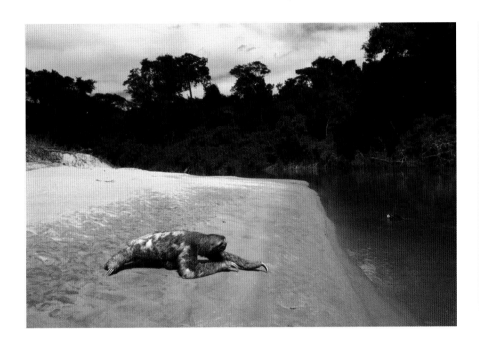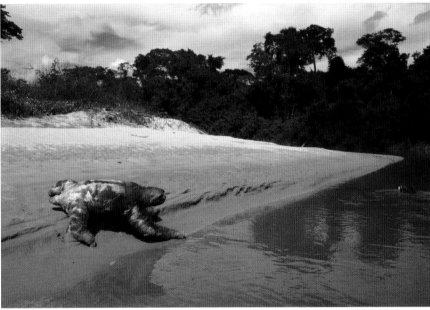

Three-toed sloth carrying a baby, Asunta River, Bolivia

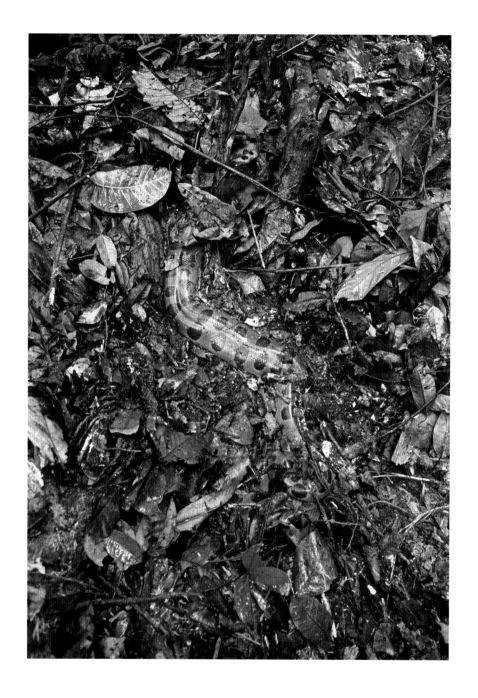

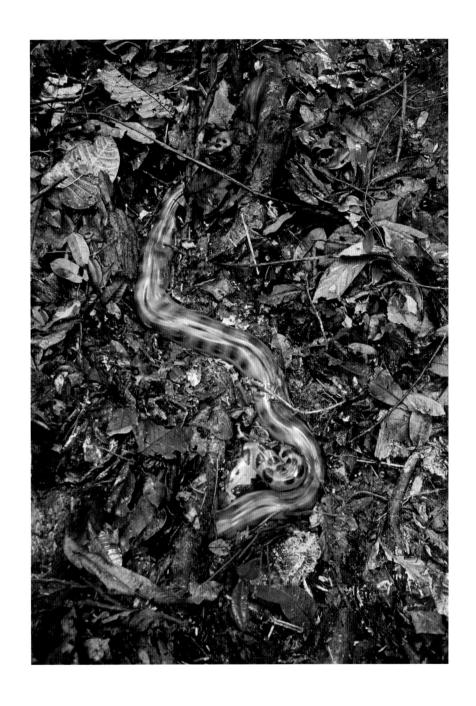

Two views of an anaconda unwinding, Heath River, Bolivia

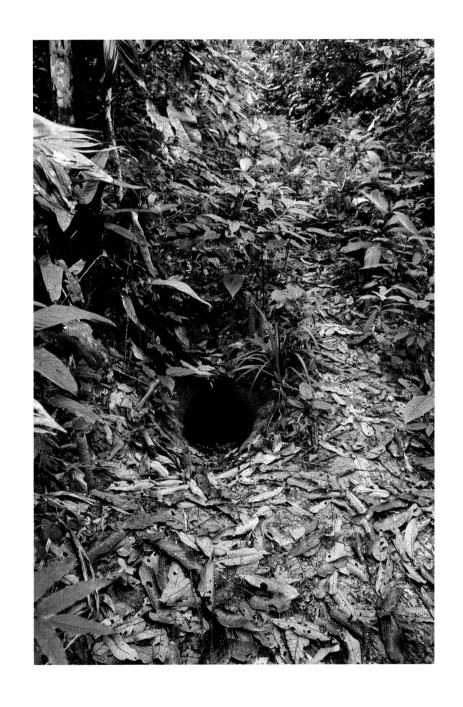

Burrow of a Giant Armadillo, Asunta River, Bolivia

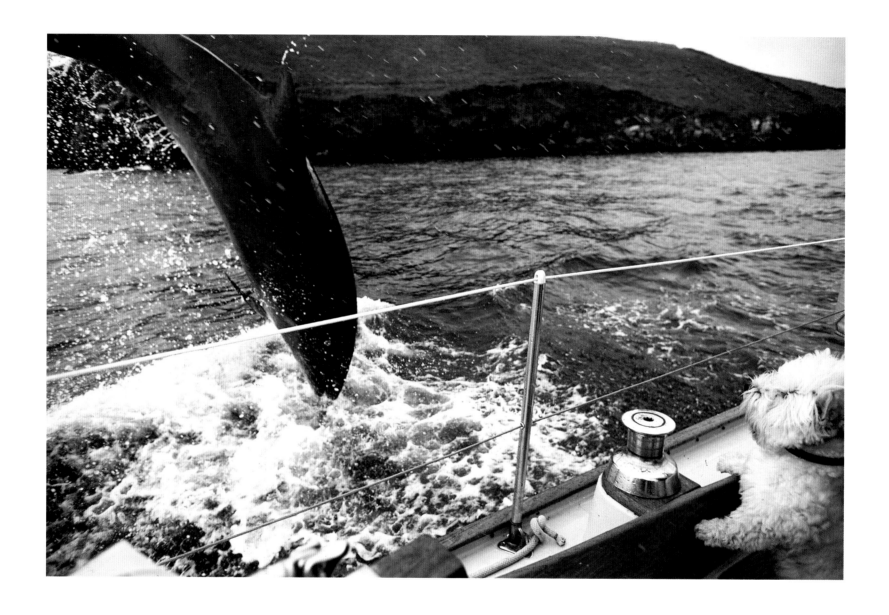

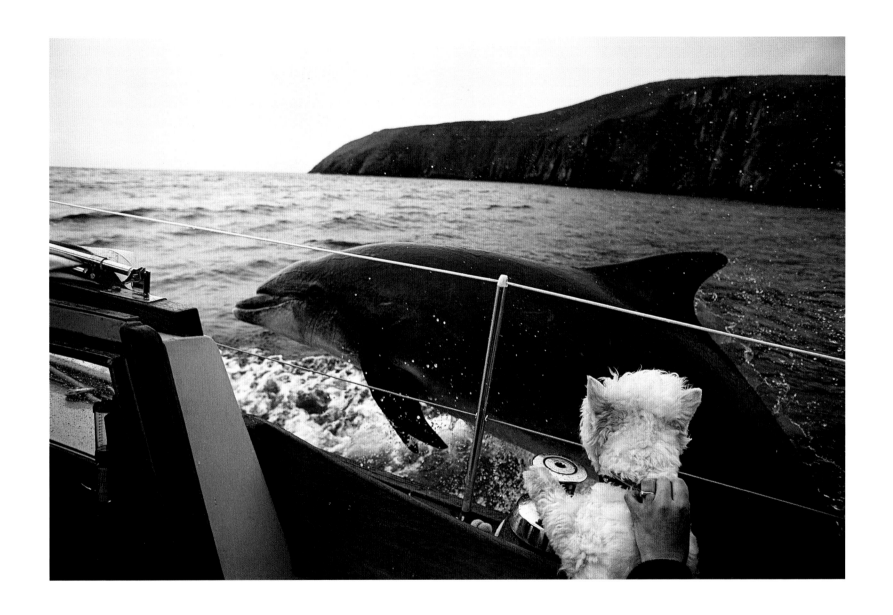

Two views of a dog and wild dolphin, Dingle Bay, Ireland

On this foggy morning there was seclusion in the mountains and it was easy to imagine the bison in their millions. That feeling was heightened when a herd of several dozen came out of the fog, thundered past and disappeared over the hill.

Just before they vanished I made this photograph and thought to myself, "It isn't over for them. They'll be back."

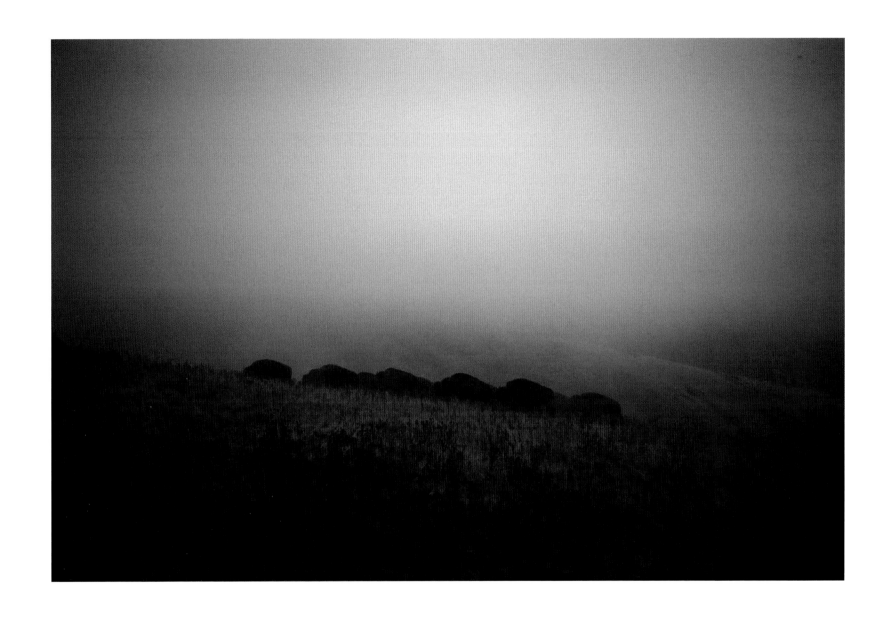

NATIONAL BISON RANGE, MONTANA

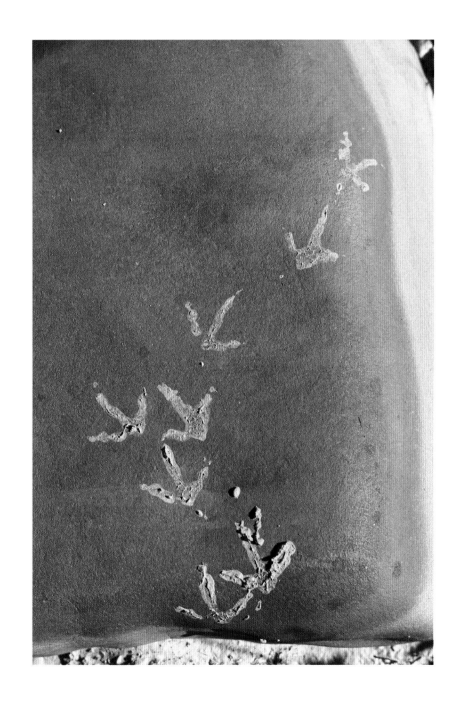

Tracks of a Sandhill Crane, Noatak River, Alaska

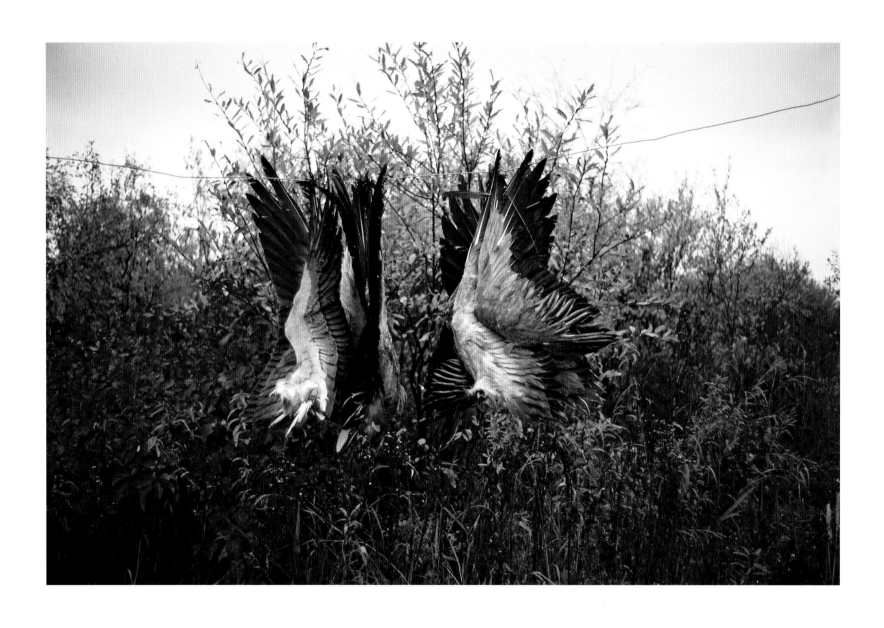

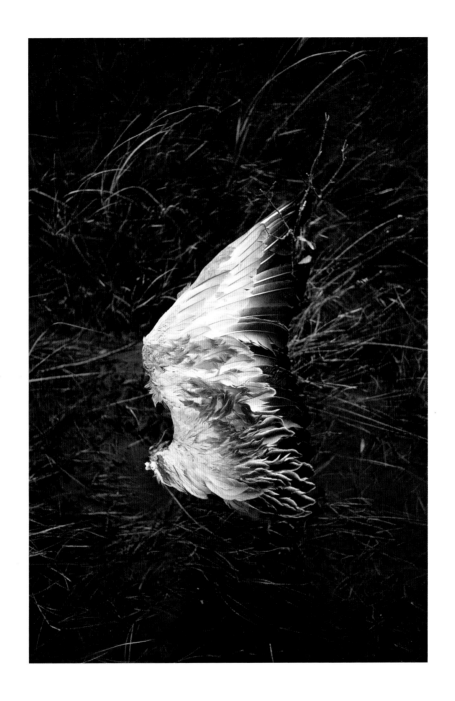

Two views of goose wings used as decoys, James Bay Lowlands, Ontario

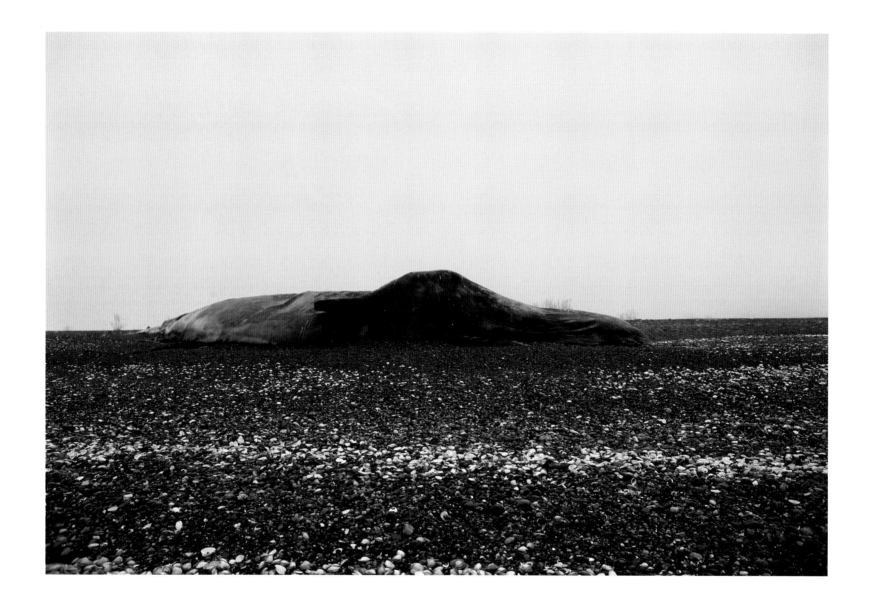

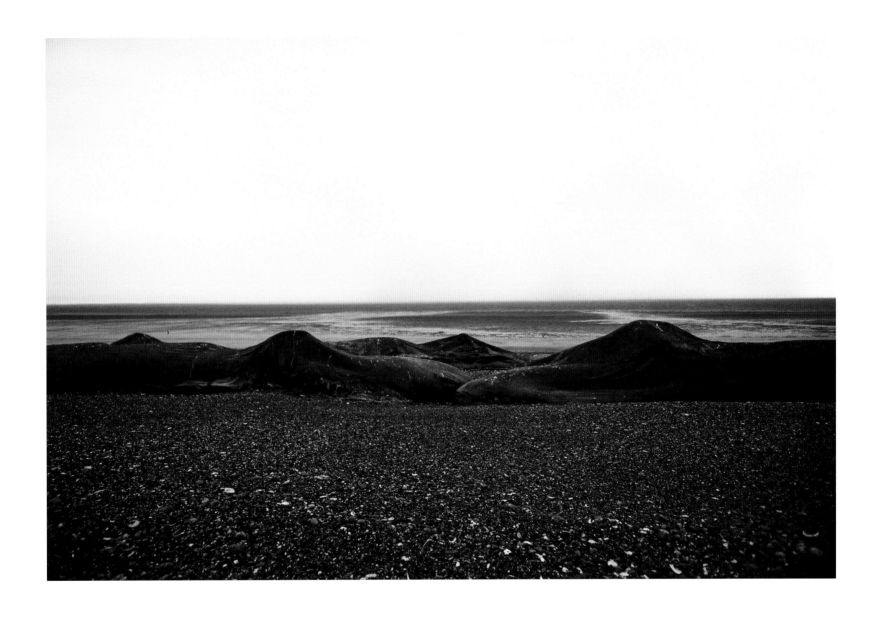

Two views of beached whales, Paramo Peninsula, Tierra del Fuego

AN OWL AND I SURPRISED EACH OTHER late one Arctic afternoon. The owl flew up suddenly from a shrub and began circling my head slowly. I was determined not to move and spoil the silent spectacle of the circling owl.

Finally it flew off and settled on another shrub. Only then did I slowly raise a camera to my eye and hold it there. If the owl returned I would simply make a snapshot of the scene. It wasn't a wildlife photograph I was after but a picture from life.

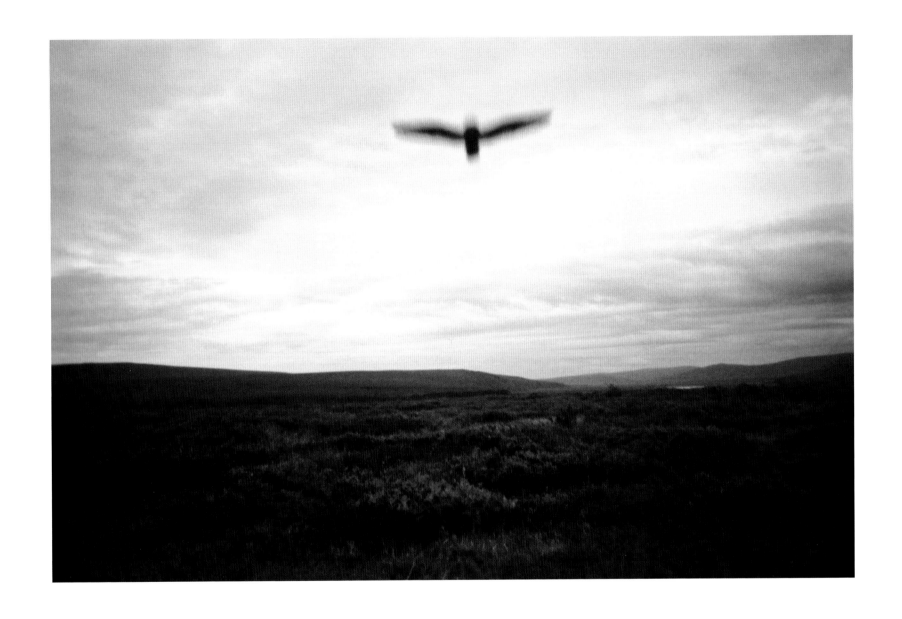

NOATAK RIVER VALLEY, ALASKA

THE BUILT WORLD

MY FAVORITE HOUSE WAS HAND BUILT OF LAVA, local lumber and salvage and sat at the entrance to a boat-filled harbor in the Galapagos. Iguanas slept on its roof, birds flew in and out of its rooms. It was the home of Karl Angermeyer, who sailed here from Germany in a small boat with his four young brothers in 1937, just ahead of the war.

Karl told that story and others one afternoon while Darwin's finches flew around our heads and perched on lamp shades. Though remote, the house seemed connected to the world, even to be at the center of things. The Duke of Edinborough had been here. It was a living house, filled with several strands of history.

While Karl spoke I was listening but also thinking hard about how to make this place come alive in a photograph. I was still thinking about that when we stepped outside. A storm had passed and the strong equatorial sun sharpened the color and texture of the scene. Our presence stirred the iguanas. They came to attention. Now the house stood forth, suggestive of a story.

Photography's power to suggest life—past, present and future—is often realized in images of the built world. Seen in isolation there can be an eloquence to a teepee, a cowboy cafe, a hunting camp or movie theater. Each speaks directly of its own history and indirectly of a larger cultural story.

Increasingly, though, the built world builds upon itself. Layers of life visibly overlap. Beside a truck depot a cemetery is submerged. Fast food is in the foreground of New England's original architecture. Globally the built world rises and spreads. Deserts and mountains disappear in a new mirage of construction until at the center of the greatest cities all is built.

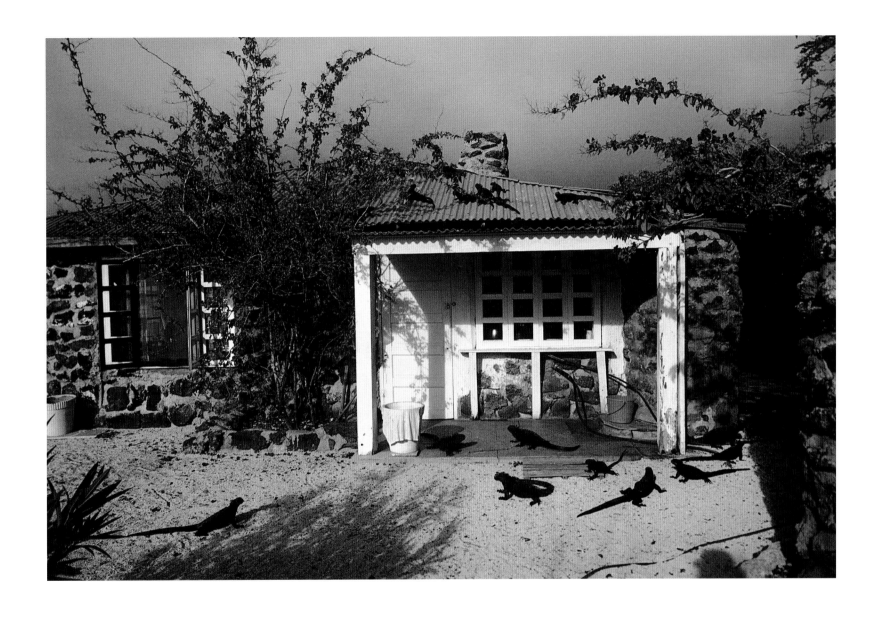

Karl Angermeyer house, Puerto Ayora, Galapagos Islands

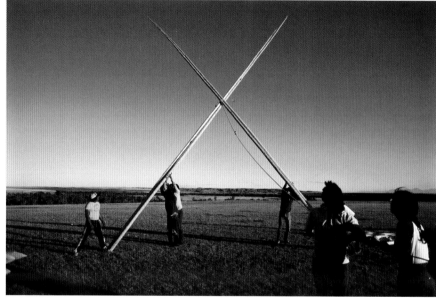

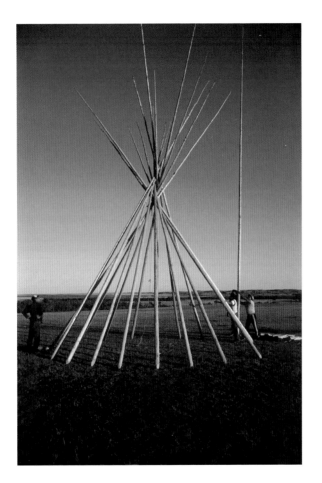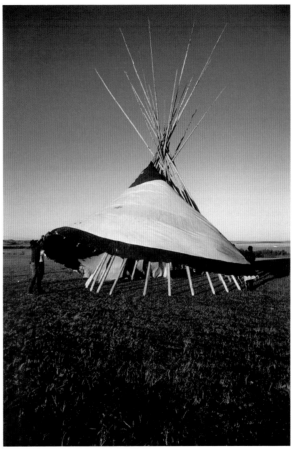

Erecting the tepee of Chief Pete Standing Alone,
Blood Indian Reserve, Standoff, Alberta, Canada

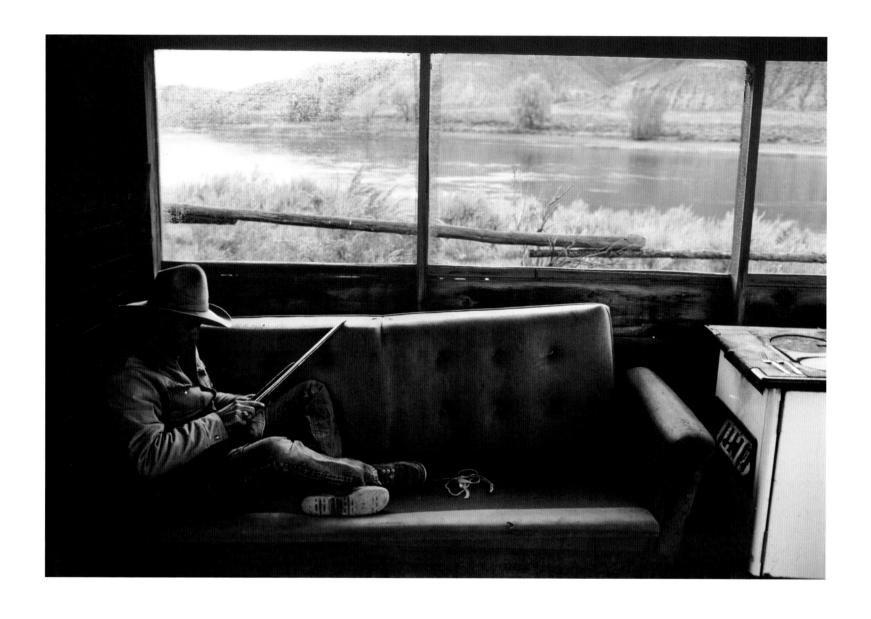

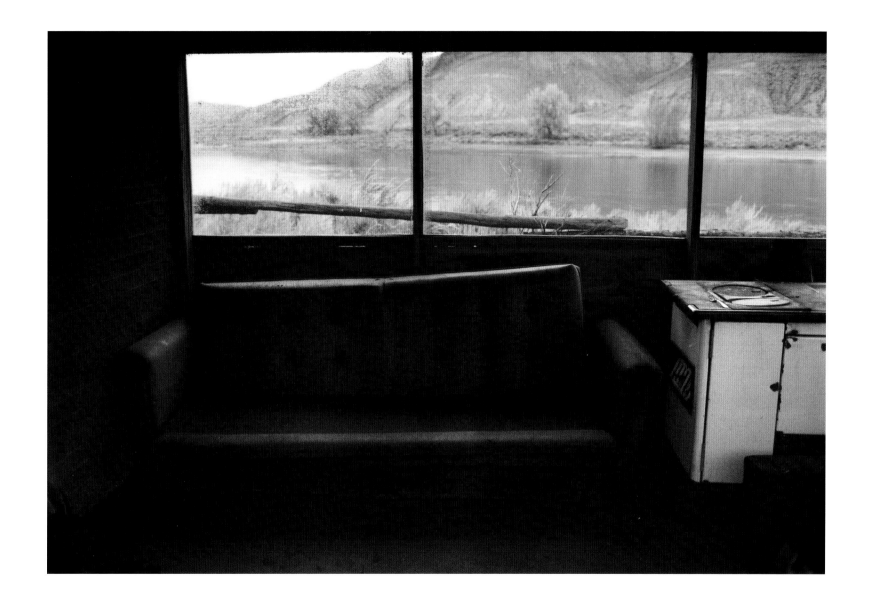

Two views of a hunting camp, Missouri Breaks, Montana

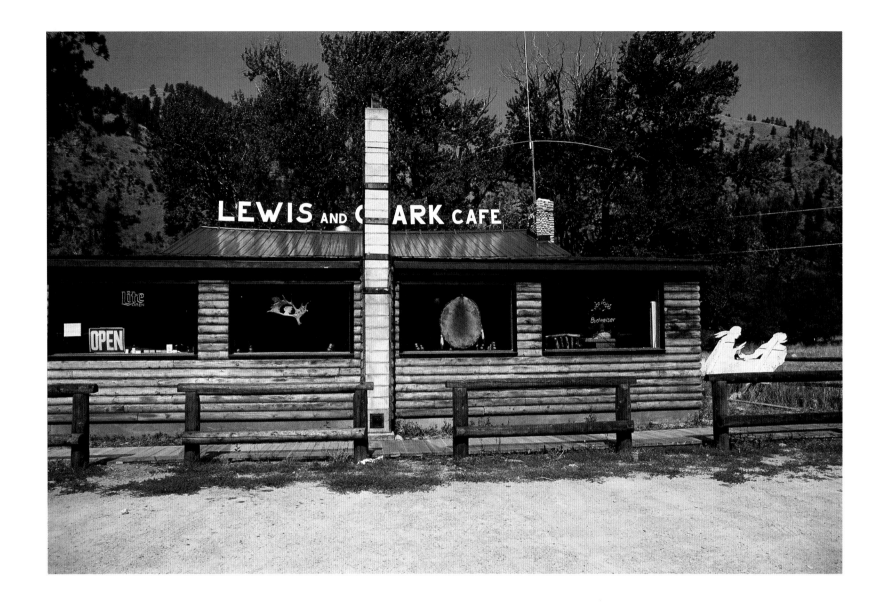

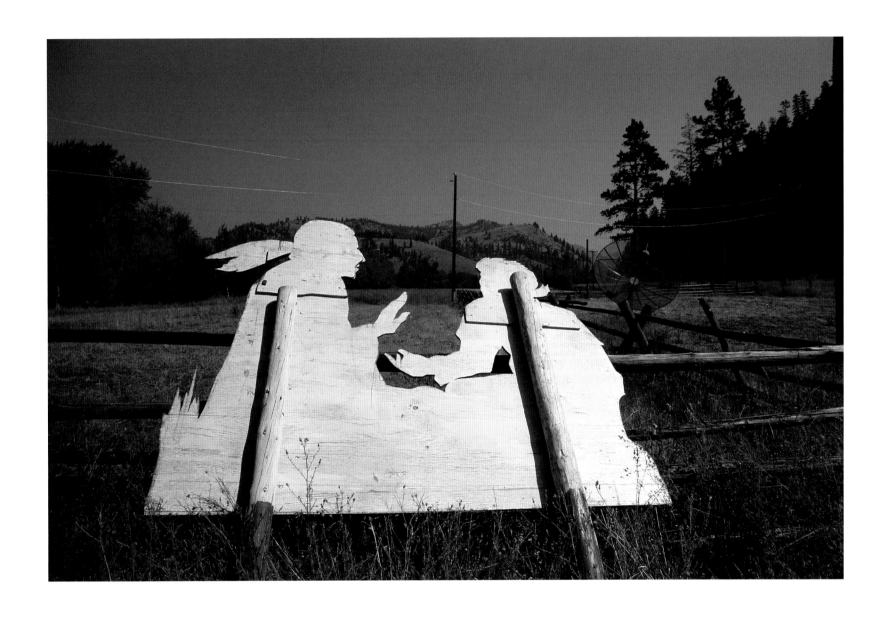

TWO VIEWS OF A CAFE AND DISCARDED BILLBOARD,
BITTERROOT MOUNTAINS, MONTANA

As a tour boat slowly made its way downstream toward the coast of Maine I got involved with composing a still-life of a snack food display against the landscape and Hopper-like house in the distance.

It gave me a chance to express a visual characteristic of our culture—how layers of life overlap and product placement is never far from view.

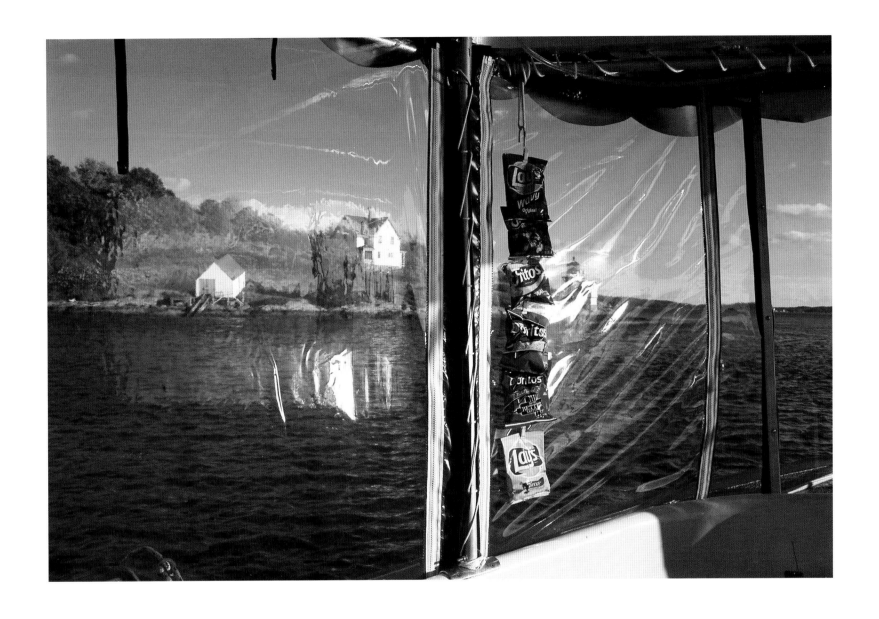

KENNEBEC RIVER, MAINE

THE BUILT WORLD ISN'T WITHOUT WHIMSY. I learned that at our home watching my dad construct scale model train layouts in the basement. Over time these layouts grew to resemble our town, with miniature grain elevators and a water tower just like the real ones visible from our house.

So it was easy to be taken in by this handmade miniature golf course. The buildings on each hole were modeled on their much larger counterparts in the nearby village.

A round of golf here was like a walking tour through someone's imaginative folk-art tribute to his hometown.

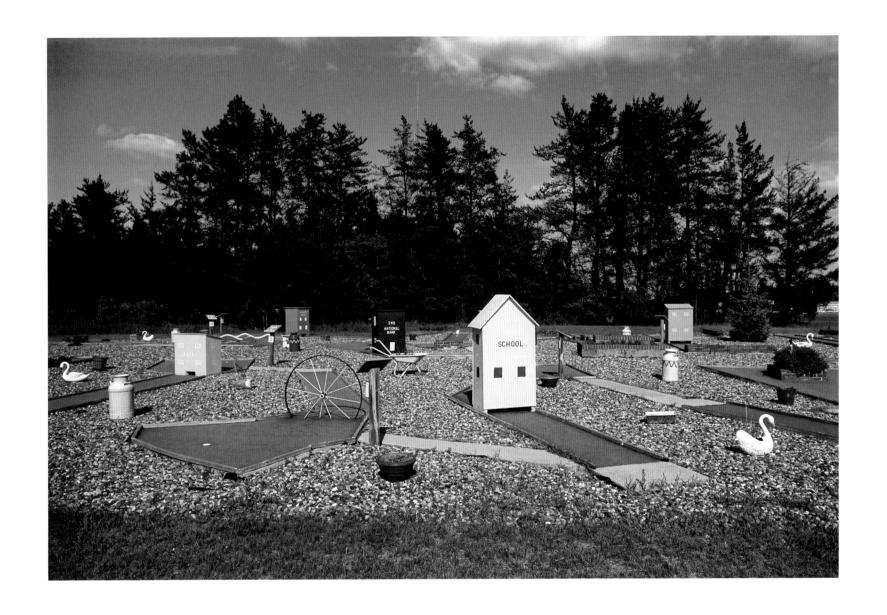

CASS LAKE, MINNESOTA

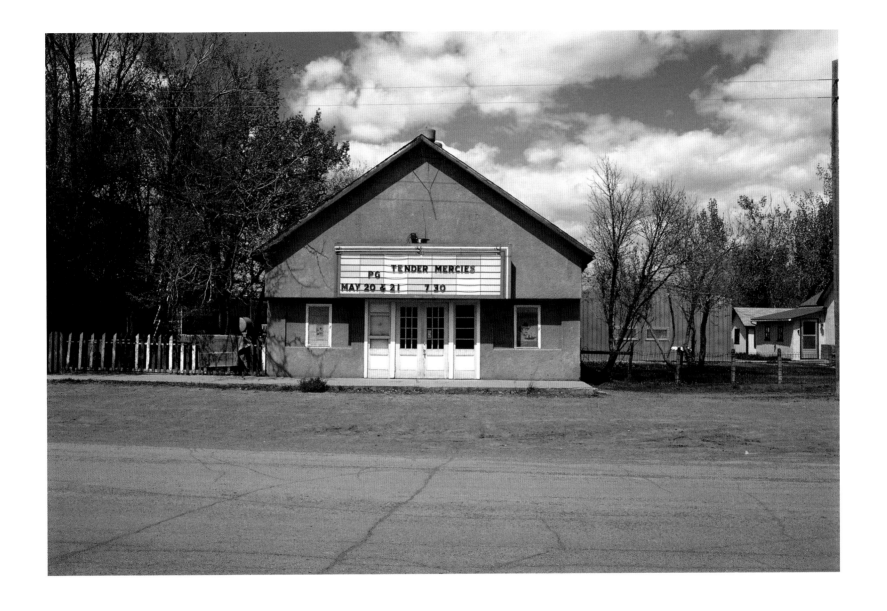

Two views of a movie theater and poster, Jordan, Montana

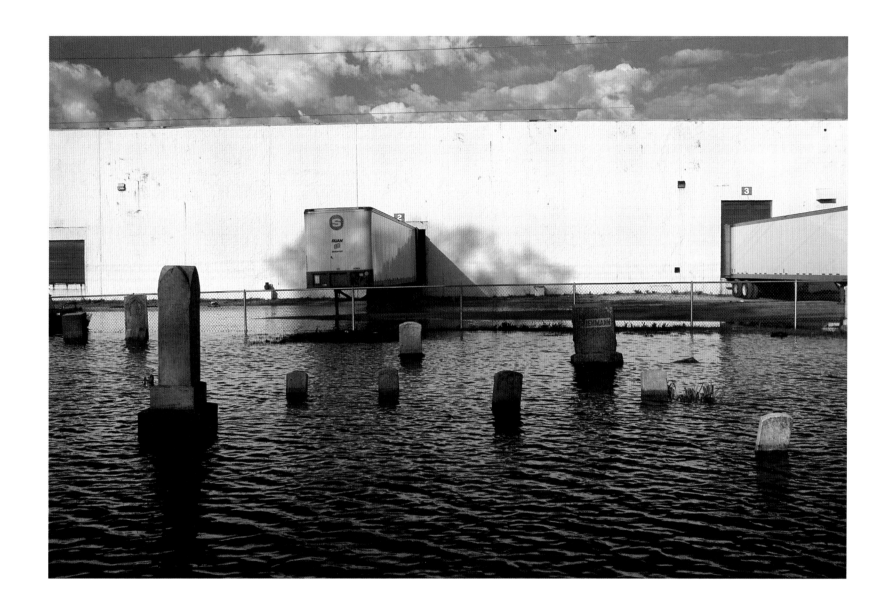

Flooded cemetery and truck depot, Mississippi River, Davenport, Iowa

Doha, once a sleepy seaport on the Persian Gulf, is being rebuilt almost from scratch into a modern metropolis. The intense pace of construction creates a white haze in the hot sky. In this atmosphere of jackhammered limestone dust Doha's new buildings shimmer on the horizon like modern mirages. But this wasn't an illusion. These towers were designed to undulate. Still, I did a double take every time the mesmerizing two towers came into view.

My fascination with the towers came up one day in a photo workshop I was conducting. A student, Marwan Zgheib, quietly spoke up: "Those towers are mine. I designed them."

"Really," I said, "that's amazing. But what are you doing in this class?"

"I've always wanted to be a photographer. It's my passion."

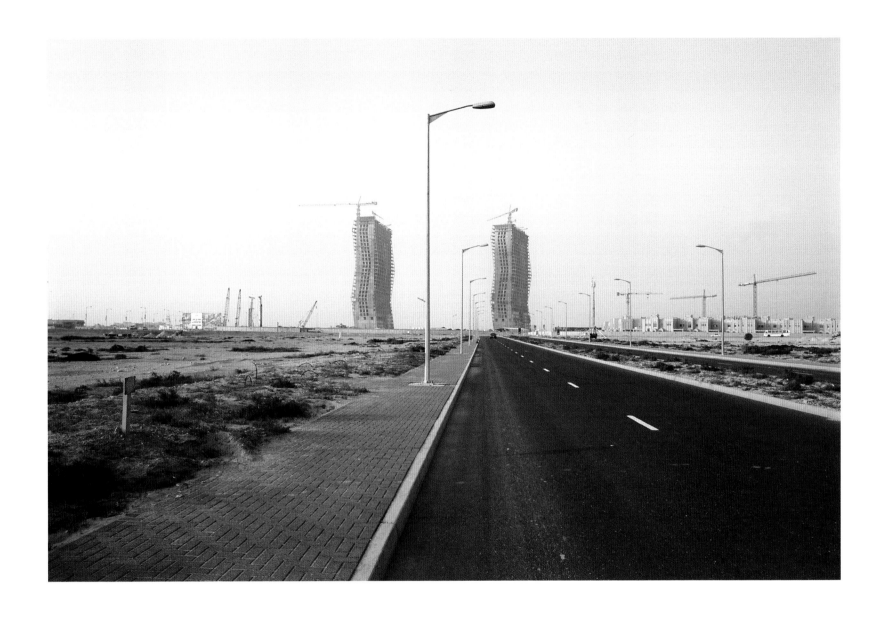

DOHA, QATAR

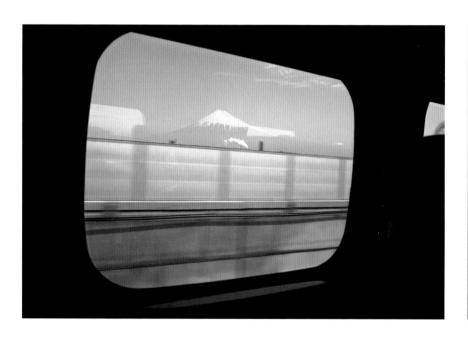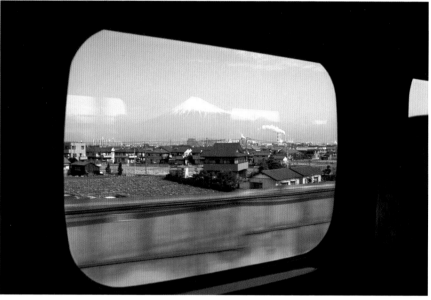

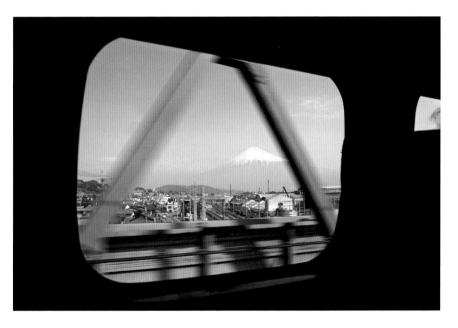 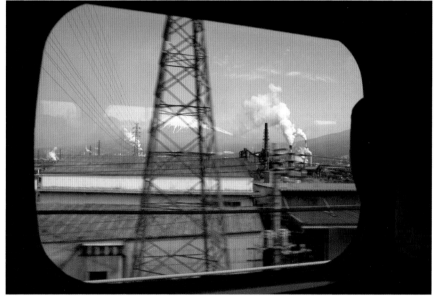

Four views of Mount Fuji (inspired by Houkusai)
bullet train, Tokyo to Kyoto

Tokyo was destroyed in the war, then rebuilt. The building never stopped. The vast and intricate city now extends to the distant mountains and out onto the ocean and there seems to be no shape or center to it. But for me there was a center and this is it.

At the end of the day I often stood at this window overlooking the roof of the hotel and felt the great weight of the city gathered and lightened.

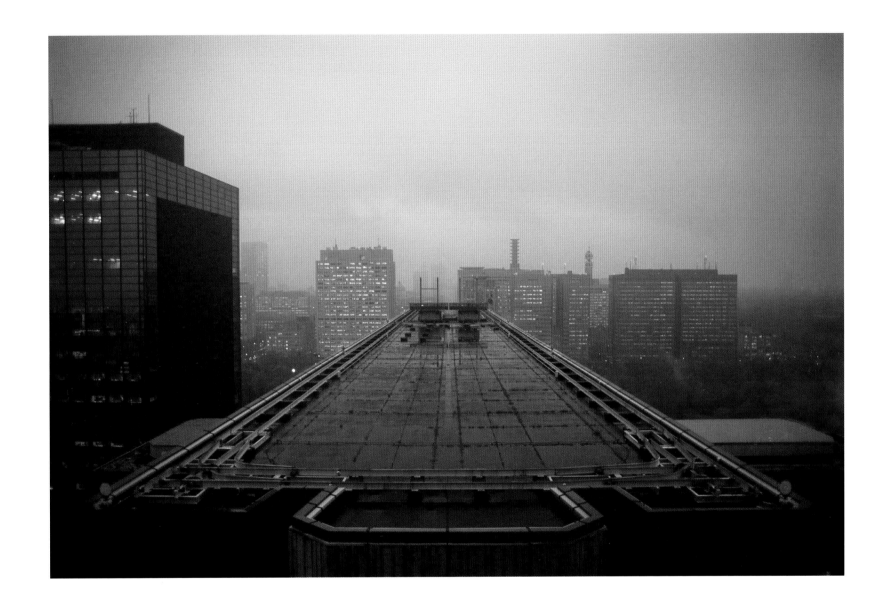

Imperial Hotel, Tokyo

Just Looking

I walked into cramped Plaza Boot in 1998 just to get out of the hot, high desert light. Right away I saw this display, stepped back as far as I could and made this picture.

There was an underlying order to the scene that appealed to me, but also an offhand quality. An atmosphere of past time was present—how long had these things been here looking like this?

How things look mattered in my upbringing and my parents came at it from different perspectives. There was a northern rigor to the way my mother controlled most of the house. The view from every window was set off by her white, ruffled curtains, starched to the stiffness of picture frames. My father's southern comfort style was symbolized by the yeasty darkroom in the fruit cellar, the only room my mother never entered.

Both their sensibilities seemed on display at Plaza Boot. It was as though one day my dad arranged my mother's shoes and she never got back to redo it. To me the display looked charmingly just right.

Making a picture just right takes time even when the thing you're photographing isn't moving. Instead you do the moving—closer, not so close, change lenses, commit to a tripod, micro compose some detail, step back, reconsider, recompose, repeat. And when it looks right it also feels right—just so.

Therefore it's not only things—the toast and the popcorn, the towels and the puddles—that have made their way into my photography, but also the poetics of them in their setting.

Ten years later I went back to Plaza Boot. The wall display was unchanged. But the already crowded store now had more shelves stacked in the way. The shoes were there, you just couldn't see them.

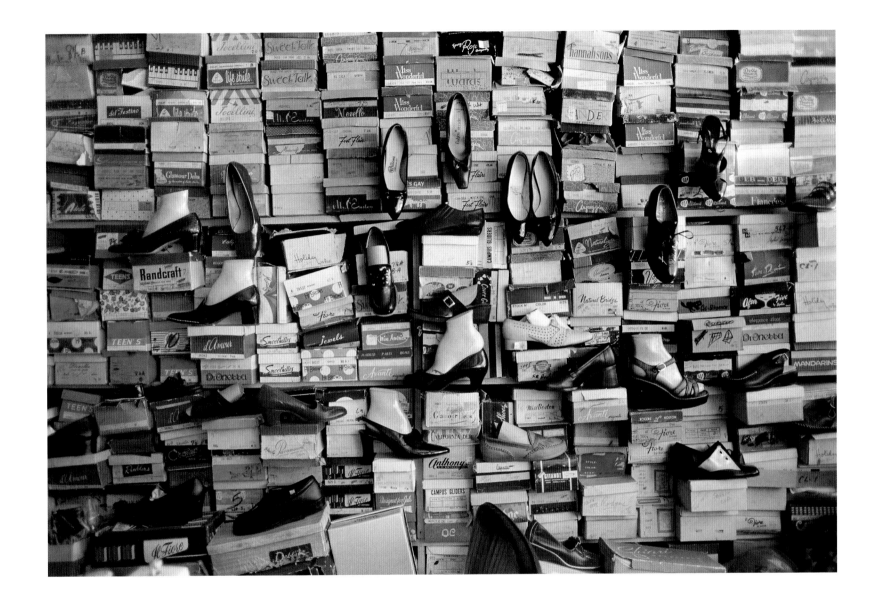

PLAZA BOOT, LAS VEGAS, NEW MEXICO

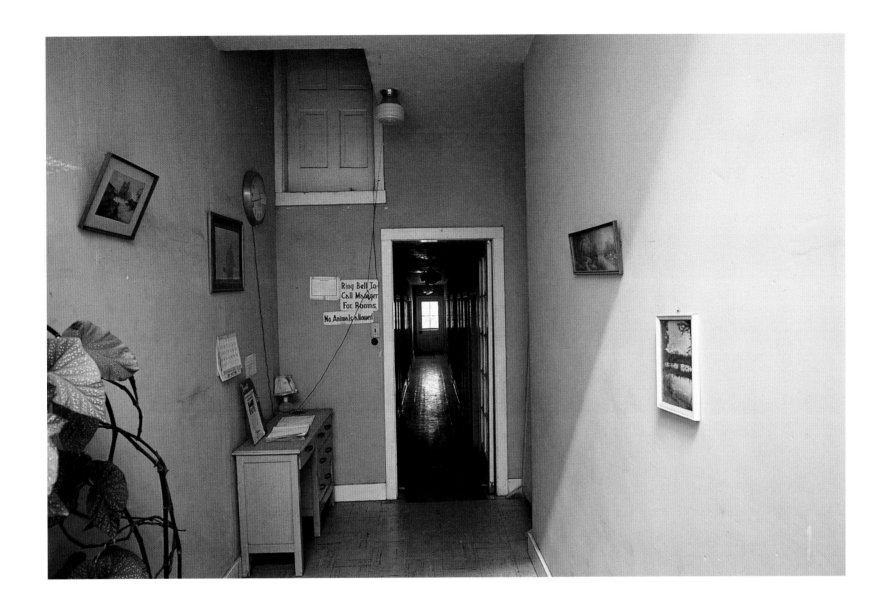

ETNA HOTEL, ETNA, CALIFORNIA

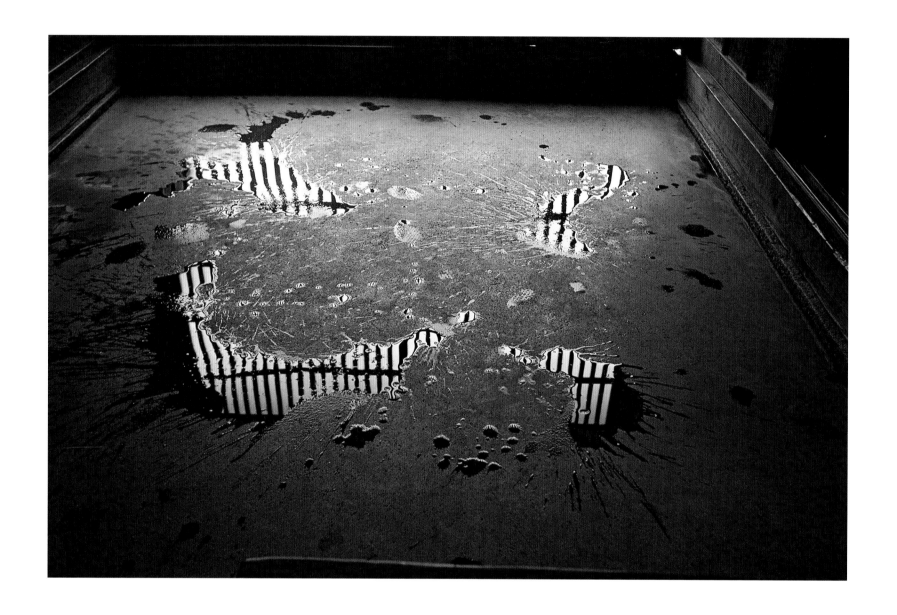

Water to wash the entrance, Tomoe Ryokan, Hagi, Japan

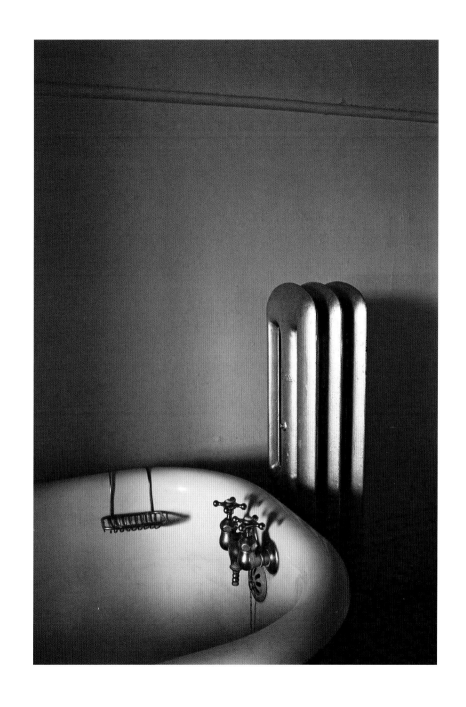

Hotel room, Fort Benton, Montana

Hotel room, Montana

There's something universal about clothes on a line. They are evidence of an everyday existence and lead one to imagine the lives within a household.

Georgia O'Keefe's earliest memory was of watching her mother hang white sheets on a line to dry. I have that early memory of my mother as well. Over the years I've continued to hang clothes out on a line. I do it to remember.

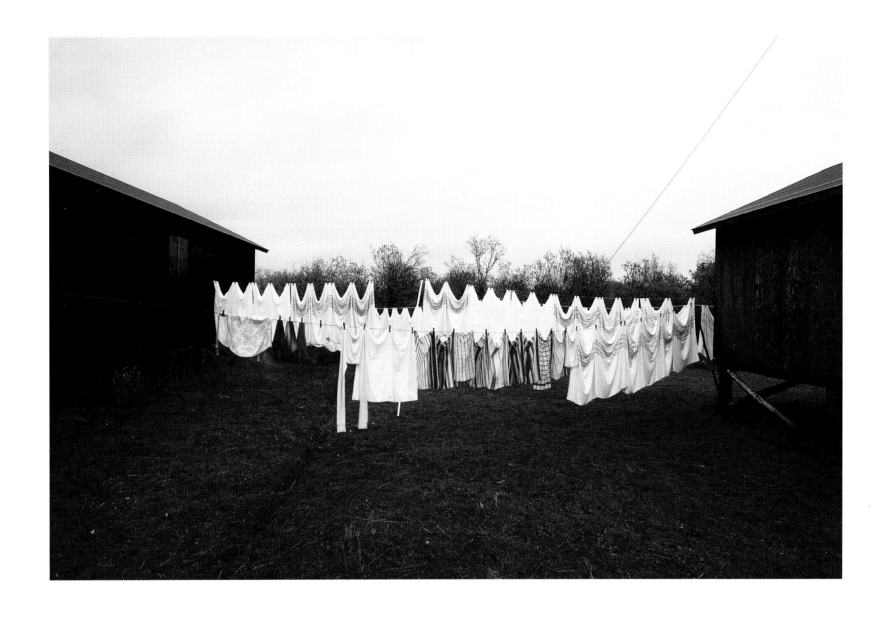

GOOSE HUNTING CAMP, MOOSONEE, ONTARIO, CANADA

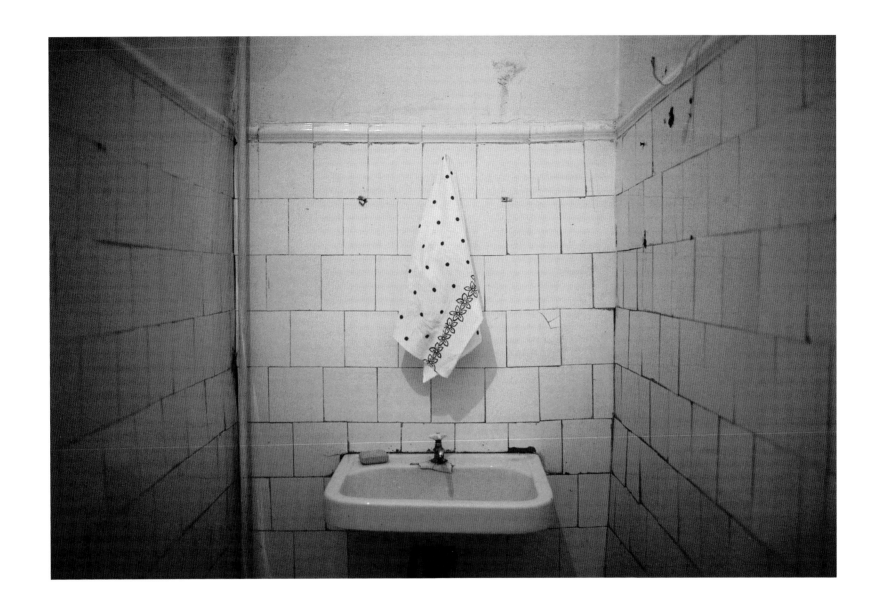

LIPETSK, RUSSIA

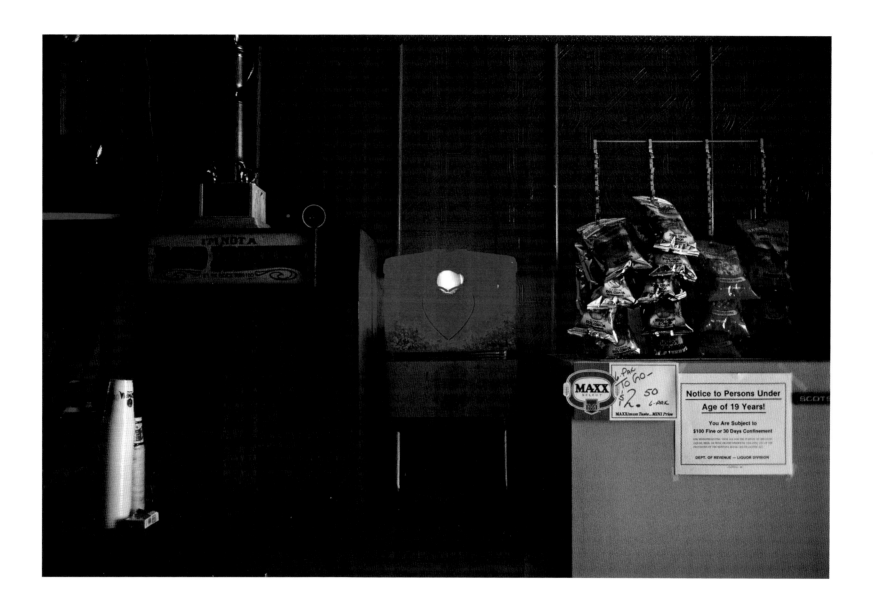

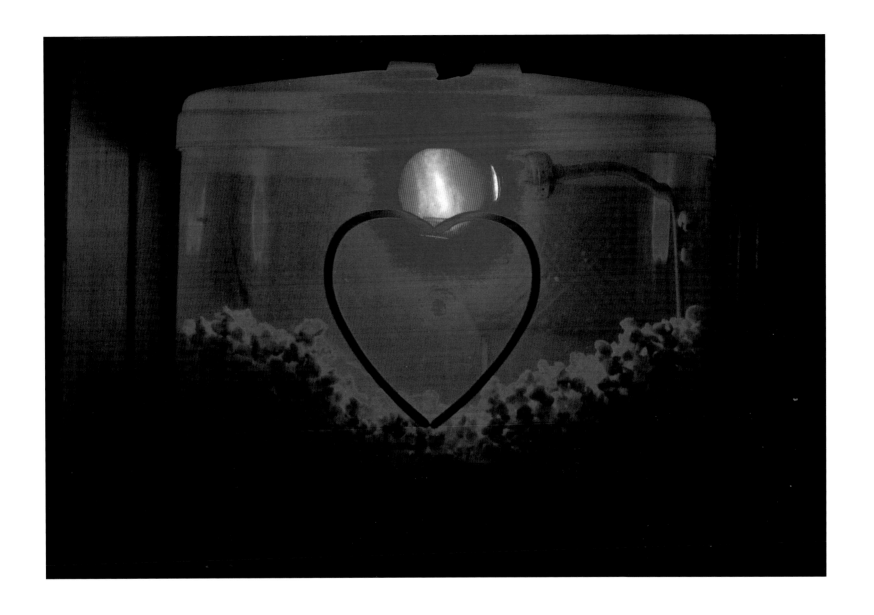

Two views of a back bar, Square Butte, Montana

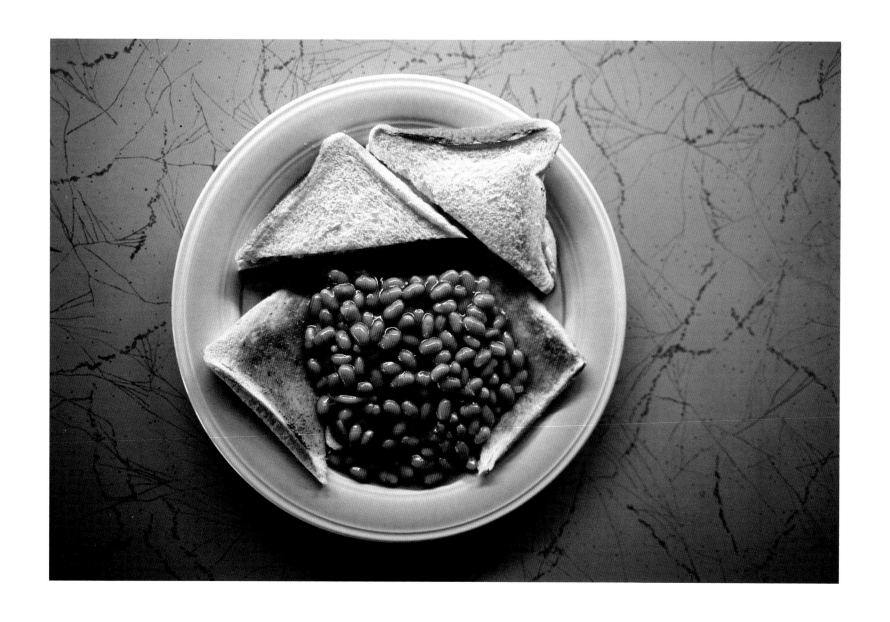

BREAKFAST, MUSGRAVE STATION, CAPE YORK PENINSULA,
QUEENSLAND, AUSTRALIA

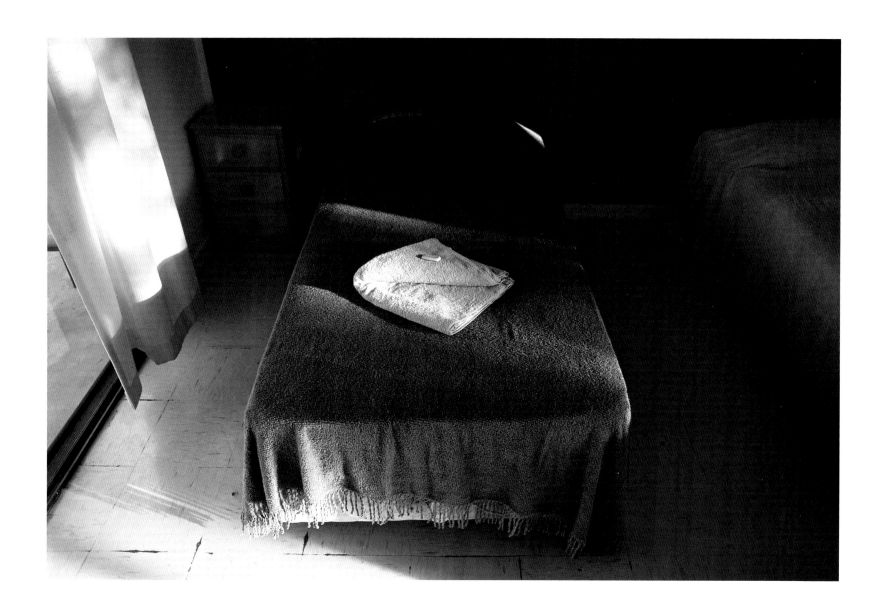

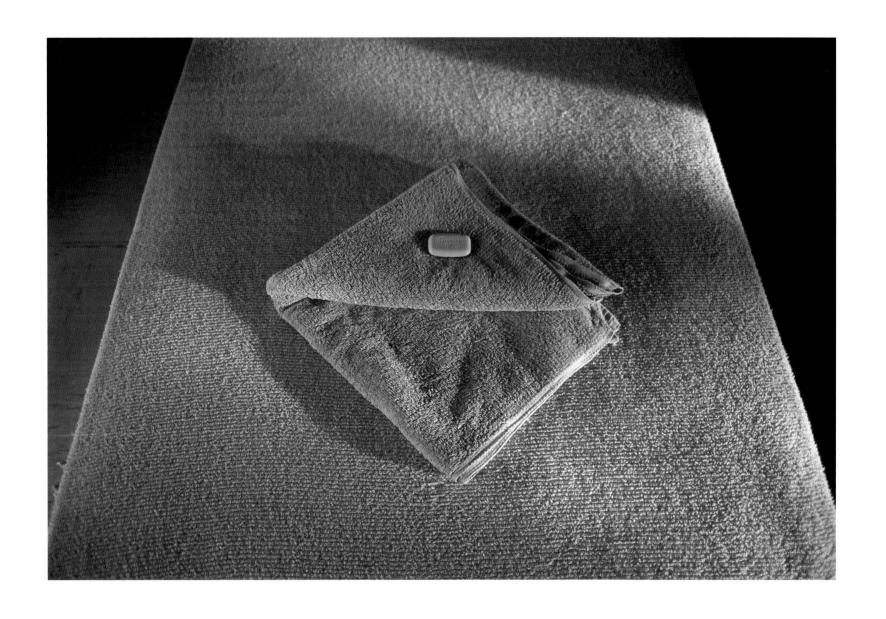

Two views of a guest room, Kowanyama Aboriginal community,
Cape York Peninsula, Queensland, Australia

Seeing Gardens

THERE WAS LITTLE TO PHOTOGRAPH on the remote river trip into the interior Amazon. Wildlife was scarce and human life nonexistent. But I wasn't unhappy. I would photograph the Amazon as I had other places—as a garden. But for three weeks the jungle pushed back hard against that possibility with a darkness and density of detail I'd never encountered.

Back in the dusty river town of Puerto we had lunch in a little open air place with glass-top tables. After lunch, when the dishes were cleared, the garden I'd been seeking snapped into view. What made it a garden was framing structure and the movement of light from the shape and surface of the glass. Those same elements made it a photograph.

Seeing gardens is like seeing life. A Russian woman takes a seat on a cold bus. On her kerchief is a sunflower. Japanese gardeners prepare a tree-planting site for the Emperor. For him they shape the soil into miniature Mount Fujis. A hailstorm tears leaves into a fresh pattern of green and white. Elsewhere pears ripen on a windowsill, frost falls unevenly on a garden and a great man's grave is quietly tended.

All of these are incidental acts of gardening but done with an appreciation of how, one day, they might be seen.

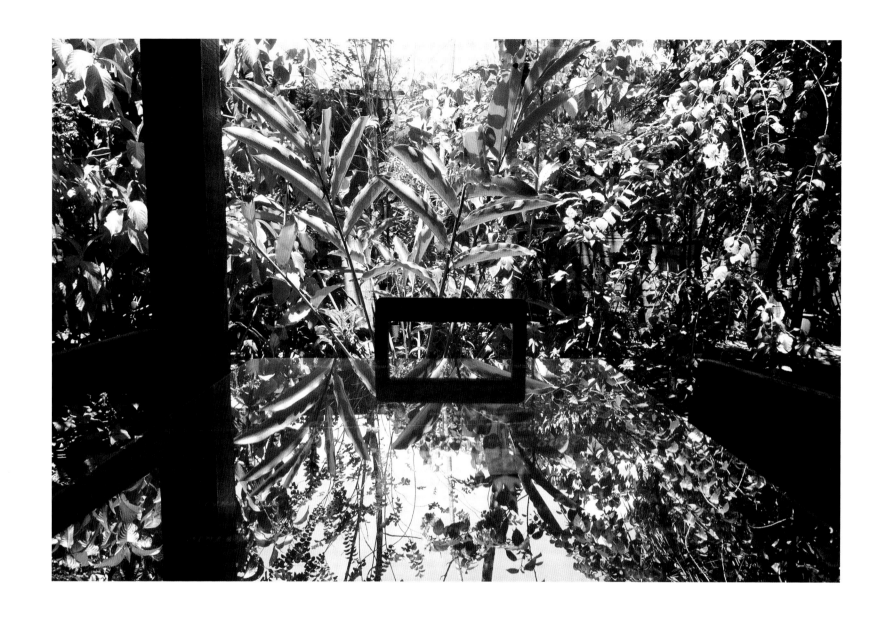

EL CALIFA RESTAURANT, PUERTO MALDONADO, PERU

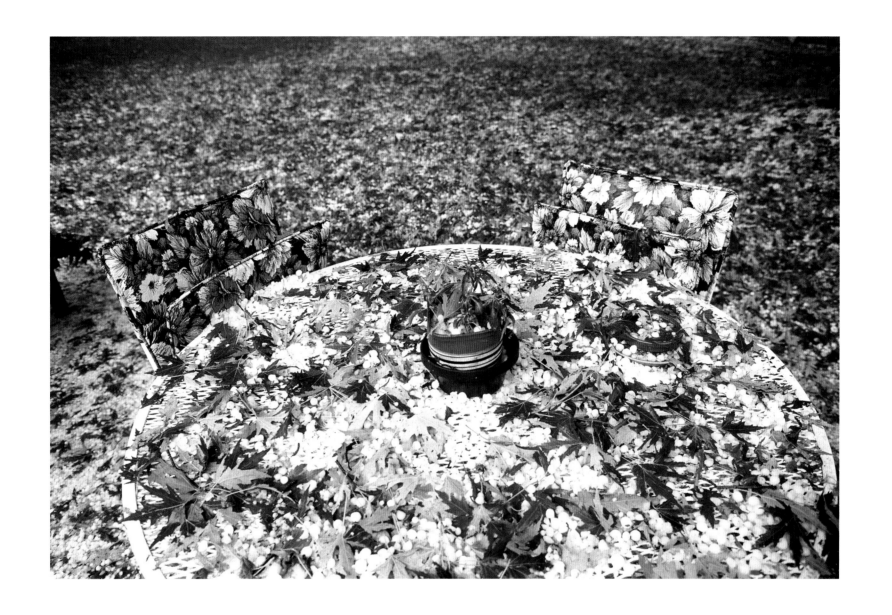

COLORADO SPRINGS, COLORADO

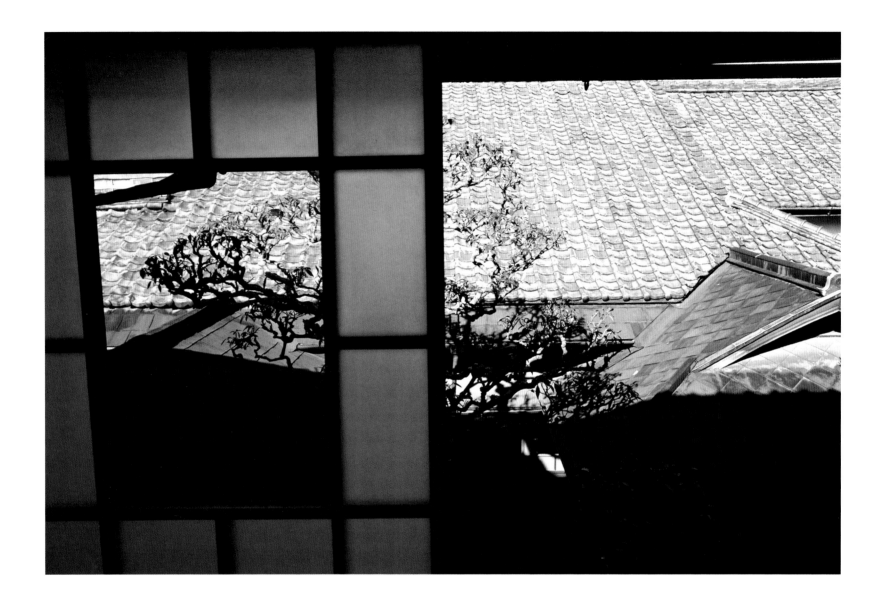

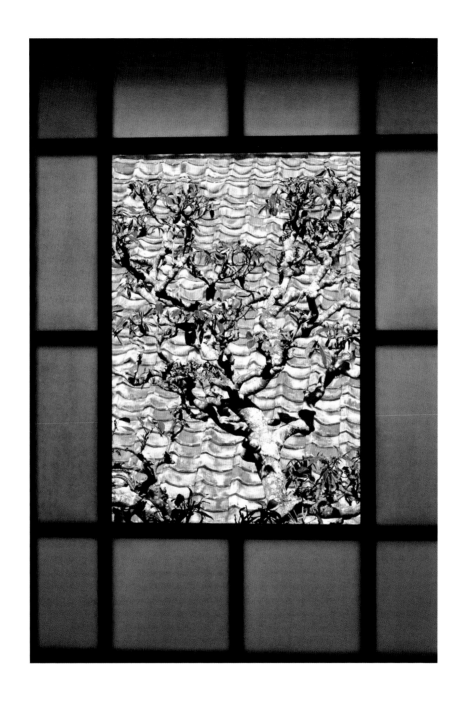

T W O V I E W S O F A S L I D I N G W I N D O W A N D C O U R T Y A R D T R E E ,
T O M O E R Y O K A N , H A G I , J A P A N

Planting site, Emperor's tree-planting ceremony, Kyushu, Japan

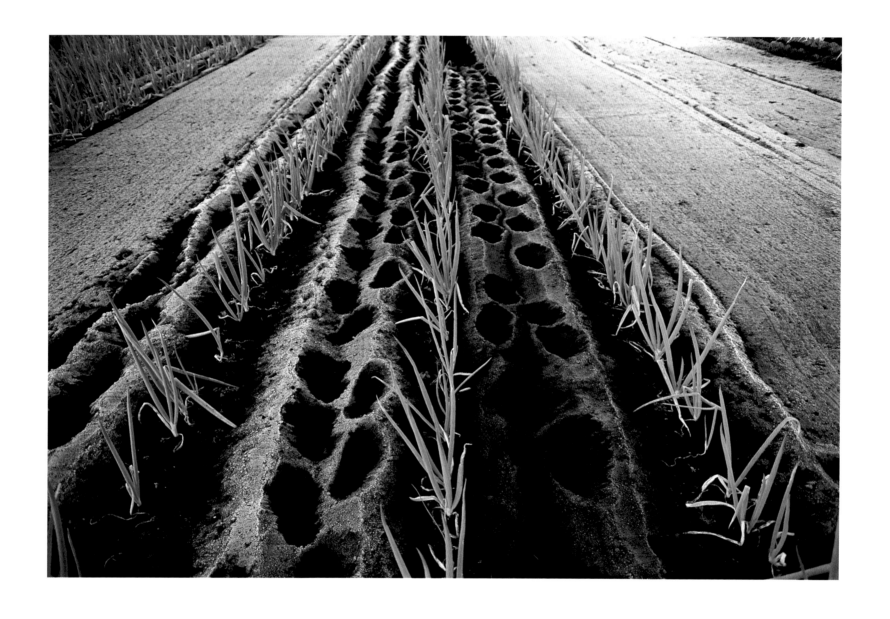

The Imperial Stock Farm, Tokyo

Lougheed's Flowers, Sudbury, Ontario

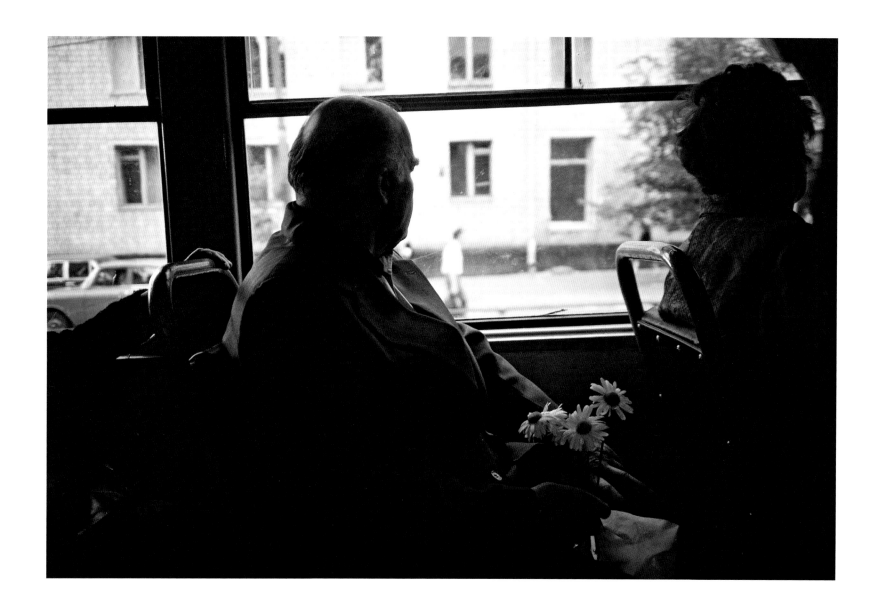

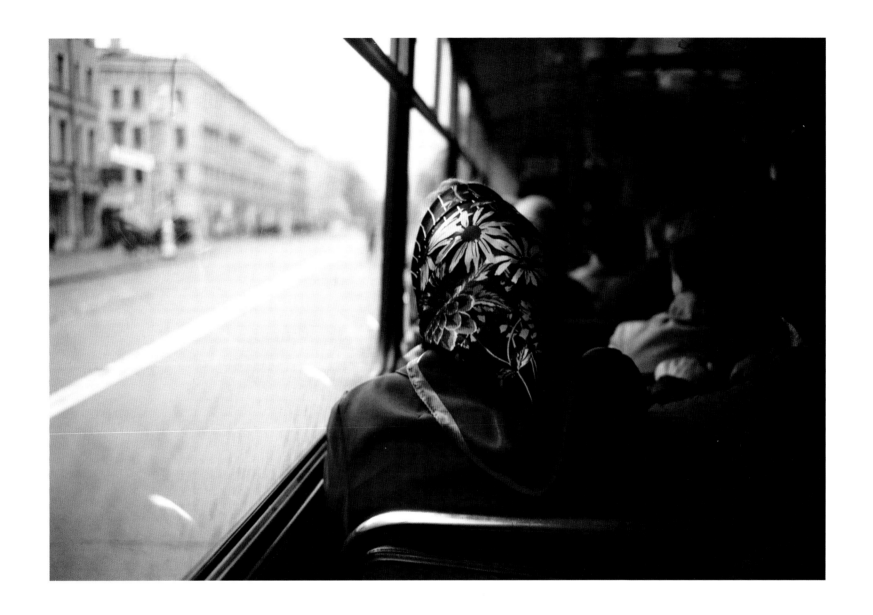

MOSCOW, RUSSIA

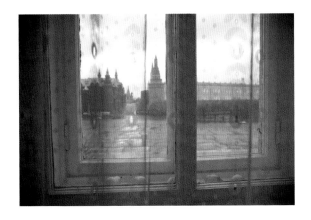 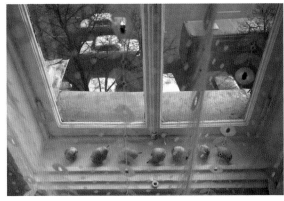 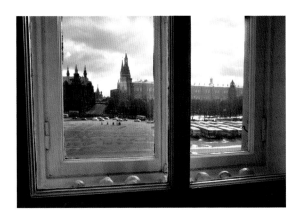

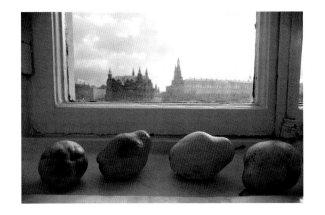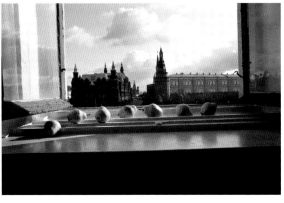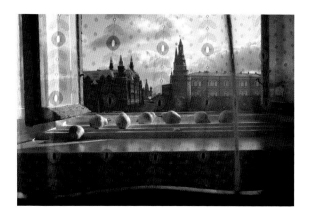

National Hotel, Moscow

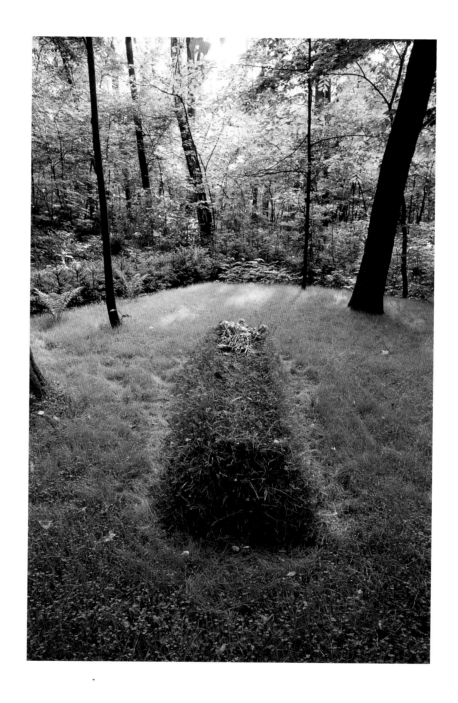

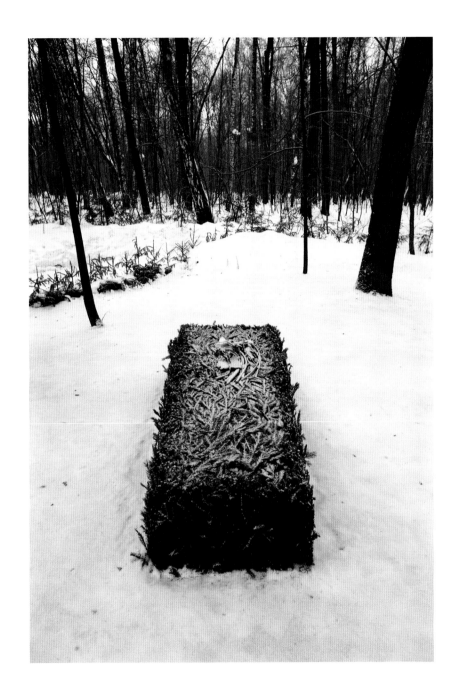

Two views of Leo Tolstoy's grave, Yasnaya Polyana, Russia

THIS IS THE WALL OF A SNUG ARTIST'S STUDIO and bedroom in the southernmost farmhouse on earth. For years it was the room of Clarita Goodall whose family ran Harberton, a vast and windswept sheep station at the tip of South America.

Clarita devoted herself to painting delicate, detailed watercolors of the region's rare wildflowers. In her quiet room there were small bouquets, pressed flowers and paints waiting to be used.

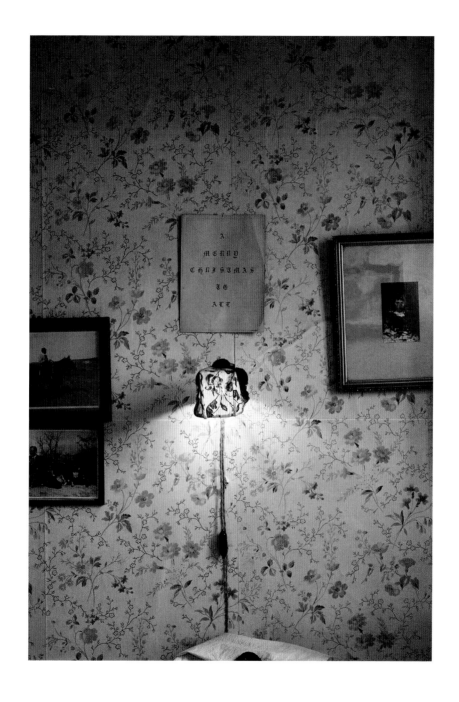

HARBORTON STATION, TIERRA DEL FUEGO

The Life of a Photograph

Ask people what kind of photograph has a life and most will say a family snapshot like this one.

It's of a family that belonged to the generation of Aborigines broken up by the Australian government in the 1930s. It was official policy to take selected Aboriginal children from their parents and rear them elsewhere. The idea was to "whiten" Australia. All that remains of many such families is a photograph. In that meaningful way this picture, like all ancestral photographs, resonates with questions about lives lived.

But what of the other many millions of impersonal photographs that populate our lives. Why are they looking at us, as familiar as our families? They are there to persuade us—to buy buttons or sodas or cigarettes or museum admissions or tell us their stories.

But to me these particular pictures are about something else. They are about photography itself: the Japanese vending machine photo resembles the color landscape pictures of my youth; the black-and-white picture of Mercedes McKee is from photography's past; the televised portrait is from photography's future; the cowboy print questions the contemporary art world's notions of originality.

Something about these pictures made me want to be more than a viewer. By re-photographing them I was giving expression to my lifelong thoughts about photography.

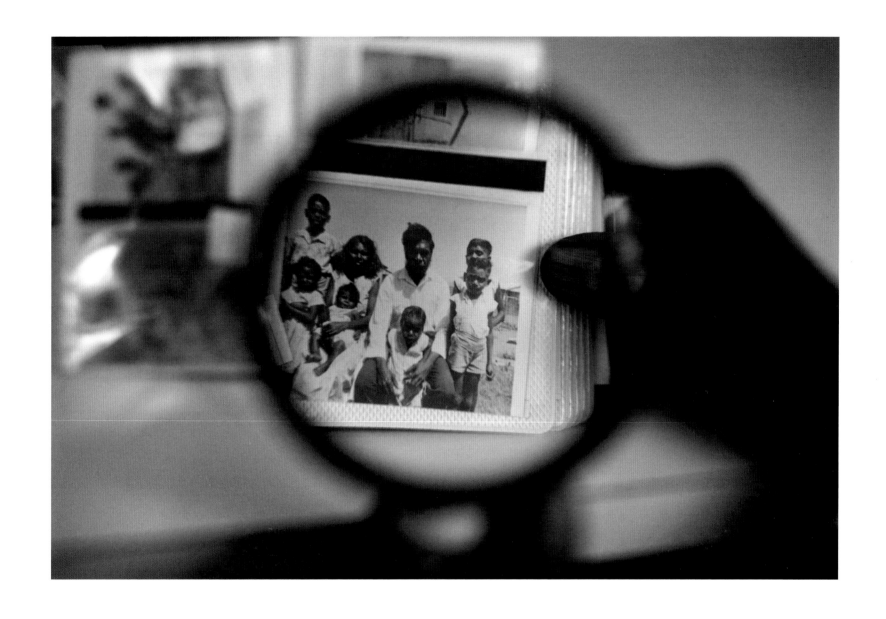

KALUMBURU MISSION, KIMBERLEY, WESTERN AUSTRALIA

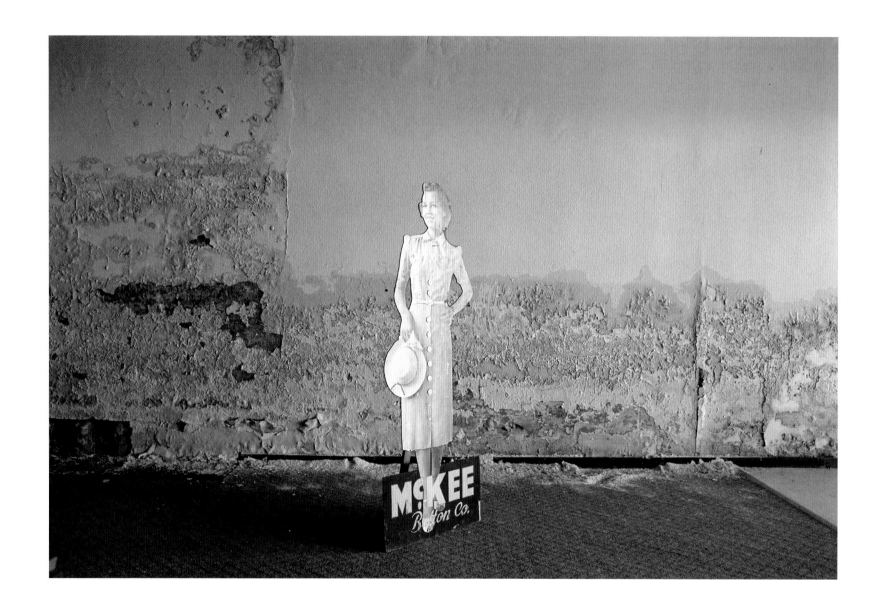

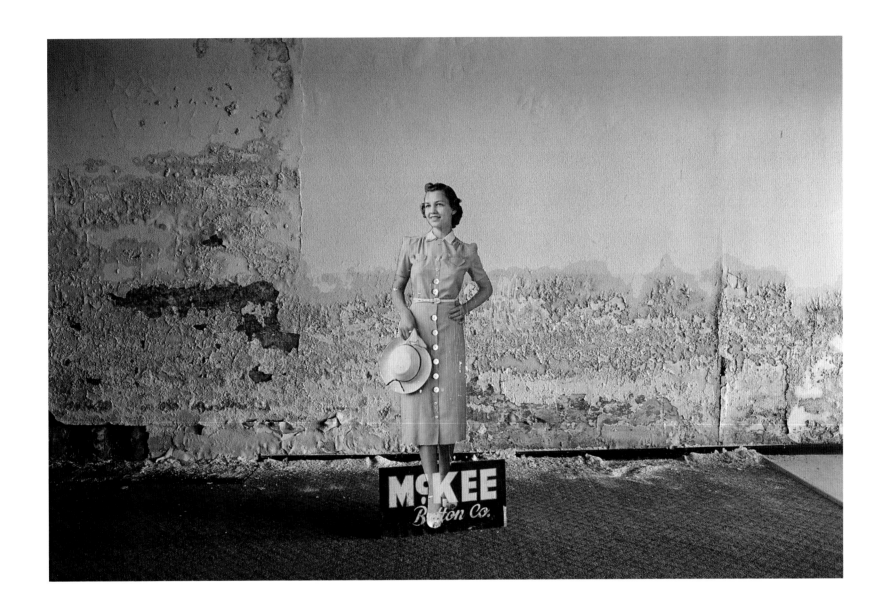

Two views of the Mercedes McKee photograph, Muscatine, Iowa

THE PHOTOGRAPH ON THE GUGGENHEIM MUSEUM BULLETIN was made by me. I photographed the cowboy in New Mexico in 1996. The photograph appeared in an advertisement for Phillip Morris Inc., which owns the copyright.

Richard Prince photographed the advertisement, stripped away any text, enlarged it, then copyrighted the result.

It became a signature image of his retrospective exhibition "Spiritual America" at the Guggenheim. He printed an edition of two. Prints, like this, from his "Cowboy" series have sold in the range of one to three million dollars.

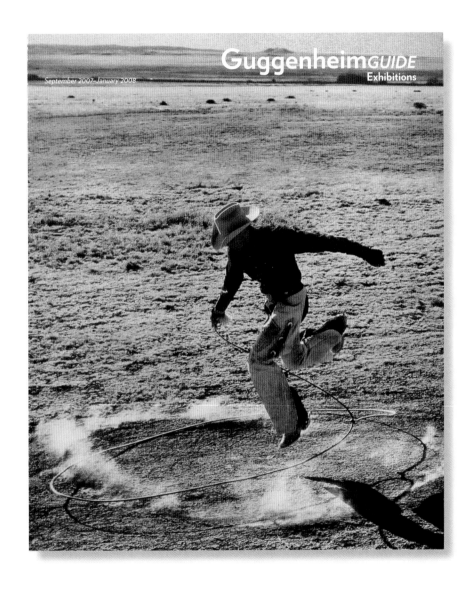

Guggenheim Musuem exhibition guide, New York,
September 2007–January 2008

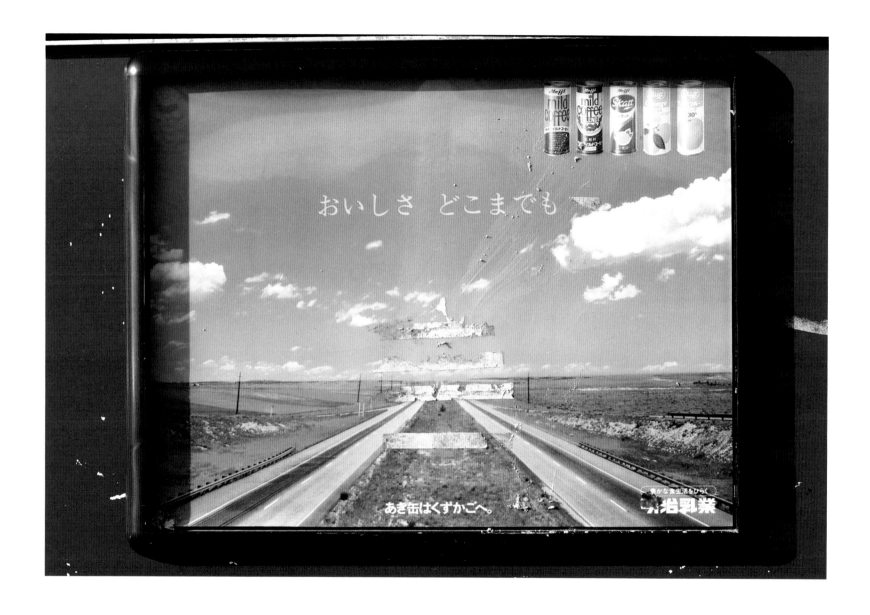

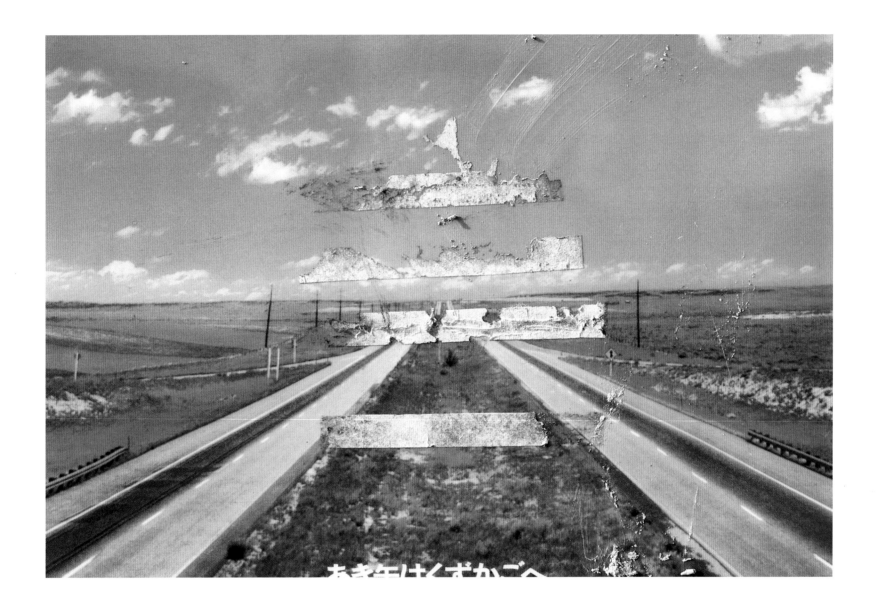

Two views of a vending machine photograph, Hagi, Japan

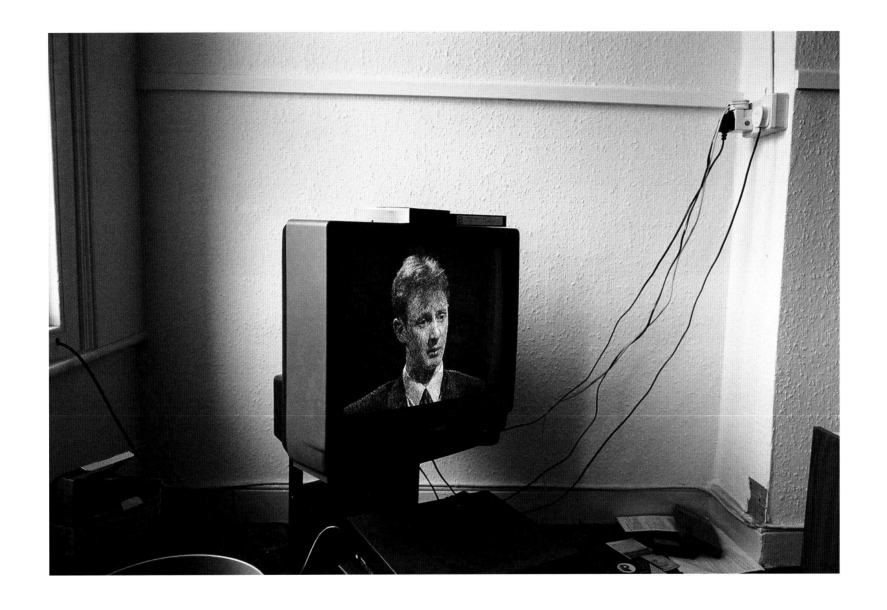

VIDEO PORTRAIT OF AN IRISHMAN ISSUING AN APPEAL FOR PEACE,
BELFAST, NORTHERN IRELAND

This is a photograph of my father watching a train depart. But it's also a picture of his soft-spoken words to me about picture taking—"look for strong diagonals; take a low angle; keep the sun to your side; bad weather makes good pictures," and most influentially, "compose and wait"—wait, in this case, for the train to depart and for him to close his coat against the cold.

I see all these things because I've lived with this photograph for almost fifty years. I know it by heart. What I no longer remember is the day itself. It was in color wasn't it? And the snow I knelt on to compose the picture in my dad's Rollei—wasn't it cold or wet or both? Surely we talked afterward—about trains or photography or what we'd do next. But all that has vanished. In its place is this photograph. The photograph is what I remember.

But for other people this picture opens a door on memory—of their father, of trains and stations and snow, of black-and-white photography, of a time in America when men wore hats like his. Because of these connections the picture has had a long life. One can't ask for more than that, unless the same picture is also the foundation upon which a life was built.

In 1961 at age sixteen I entered the picture in the Kodak National High School Photography Contest. It won the smallest prize, Honorable Mention, Junior Division, $25. Naturally I wanted to win the $500 Grand Prize. But I wasn't unhappy. My name was listed in the back of the awards booklet. And the contest connected me with the word "National" for the first time. Someone other than me cared about a picture I'd made. The photograph had a life, and so did I.

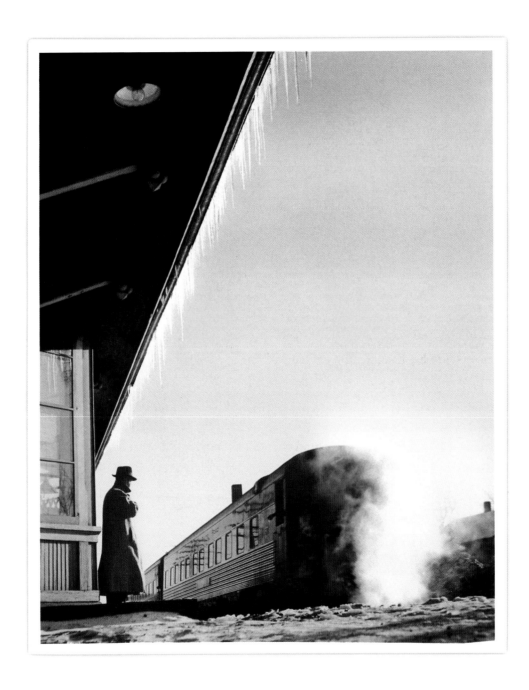

THAD S. ABELL AND THE LAKE SHORE LIMITED, PAINESVILLE, OHIO, 1960

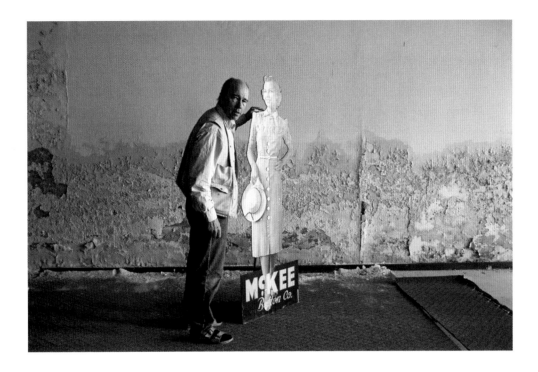

THIS PHOTOGRAPH BY MY AUSTRALIAN FRIEND Kerry Trapnell catches me in the middle of a conversation. I'm asking Kerry about the quality of light reflecting from a vintage photograph. We're collaborating on the making of a new image of that photograph.

Conversation and collaboration are at the heart of this book. The conversation began with Nina Hoffman, Executive Vice President of the National Geographic Society, and Kevin Mulroy, Publisher of National Geographic Books, who approved the initial idea and supported the book throughout. The conversation continued with the designer Cameron Zotter and with Chris Brown, Technical Director of Manufacturing. Their careful work resulted in the clean design and fine printing of the book.

The most continuous conversation has been with Leah Bendavid-Val, Director of Photography Book Publishing. We have collaborated on five books of photographs including *Sam Abell: The Photographic Life* for which Leah was editor and author.

THE LIFE OF A PHOTOGRAPH

SAM ABELL

Published by the National Geographic Society
John M. Fahey, Jr. President and Chief Executive Officer
Gilbert M. Grosvenor, Chairman of the Board
Tim T. Kelly, President, Global Media Group
John Q. Griffin, President, Publishing
Nina D. Hoffman, Executive Vice President;
President, Book Publishing Group

Prepared by the Book Division
Kevin Mulroy, Senior Vice President and Publisher
Leah Bendavid-Val, Director of Photography Publishing
Marianne R. Koszorus, Director of Design
Barbara Brownell Grogen, Executive Editor
Elizabeth Newhouse, Director of Travel Publishing
Carl Mehler, Director of Maps

Staff for This Book
Leah Bendavid-Val, Editor
Cameron Zotter, Designer
Mike Horenstein, Production Manager
Keren Veisblatt, Intern

Jennifer A. Thornton, Managing Editor
Gary Colbert, Production Director
Meredith C. Wilcox, Administrative Director, Illustrations

Manufacturing and Quality Management
Christopher A. Liedel, Chief Financial Officer
Phillip L. Schlosser, Vice President
Chris Brown, Technical Director
Nicole Elliott, Manager
Monika D. Lynde, Manager
Rachel Faulise, Manager

All photographs are 35mm film, printed full frame

Founded in 1888, the National Geographic Society is one of the largest nonprofit scientific and educational organizations in the world. It reaches more than 285 million people worldwide each month through its official journal, *National Geographic*, and its four other magazines; the National Geographic Channel; television documentaries; radio programs; films; books; videos and DVDs; maps; and interactive media. National Geographic has funded more than 8,000 scientific research projects and supports an education program combating geographic illiteracy.

For more information, please call 1-800-NGS LINE (647-5463) or write to the following address:

National Geographic Society
1145 17th Street N.W.
Washington, D.C. 20036-4688 U.S.A.

Visit us online at www.nationalgeographic.com/books

For information about special discounts for bulk purchases, please contact National Geographic Books Special Sales: ngspecsales@ngs.org

For rights or permissions inquiries, please contact National Geographic Books Subsidiary Rights: ngbookrights@ngs.org

Focal Point is an imprint of National Geographic Books

ISBN: 978-1-4262-0329-9

Printed in China